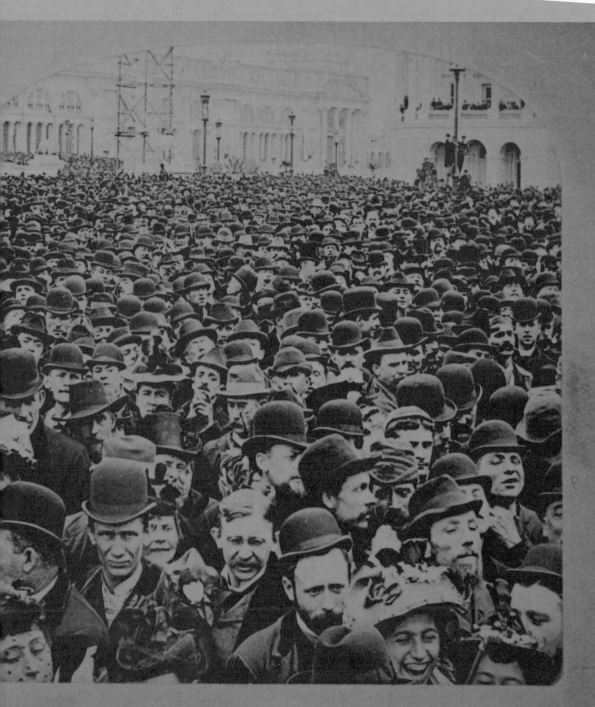

7929.  The Surging Sea of Humanity at the opening of the
Columbian Exposition.

# HOAXES, HUMBUGS

## AND SPECTACLES

# Strange, Startling, and Stupendous!!

Treat for innocent age and simpering youth!
Come late, stay early, and avoid the canaille!

**SEE** ALL THE WONDERS OF THE AGE!
The wonderful living Pincushion and Fat Woman! . . . Stick 'em way in! All Try!

THE CIRCASSIAN BEAUTY, wreathed with snakes!
whose coiffure is the envy of the 7 Sutherland Sisters!

The 4-headed Wonder! ❋ The Living Skeleton!
All true to life and brimming with local color!

THE STRONG MAN! | HAVE A LOOK AT THE
who can lift a condition with one hand, | "SOCIAL BORE!"
to say nothing of horse and wagon! | The latest result of scientific research!

**THE GIANTESS!**
Absolutely the Tallest Talker in the World!
Don't be afraid to ask her questions!

THE MERMAID!--THE AQUATIC WONDER!
Quite in the social swim.--beats the Rhine Maidens all hollow!!

**Continuous Ring Performance!**
Consisting of marvellously trained Animals! Feats of astounding Acrobatic Daring!
And--most thrilling event of the age!--

ONLY ORIGINAL BEN HUR CHARIOT RACE!!

**TWO AFRICAN MONKEYS!**
2 COUNT 'EM! 2

**DON'T** fail to visit the Grab-Bag and | COME ONE! COME ALL!
Shooting-Galleries! . . Hit the | Feed the Elephant peanuts, nit!
African in the face and you get | Do Not Tease the Polar Bear!!
a good cigar! Hit him again! |

**NOTE!** Guests may retain these as souvenirs, or on payment
of 5 dollars they may be had from the ushers! . . . .
SAVE MONEY AND DO YOUR OWN USHING!

# HOAXES, HUMBUGS
# AND SPECTACLES

**ASTONISHING PHOTOGRAPHS OF**

**SMELT WRESTLERS, HUMAN PROJECTILES,**

**GIANT HAILSTONES, CONTORTIONISTS,**

**ELEPHANT IMPERSONATORS,**

**AND MUCH, MUCH MORE!**

# MARK SLOAN

**WITH ROGER MANLEY AND MICHELLE VAN PARYS**

# FOREWORD BY ROY BLOUNT, JR.

VILLARD BOOKS 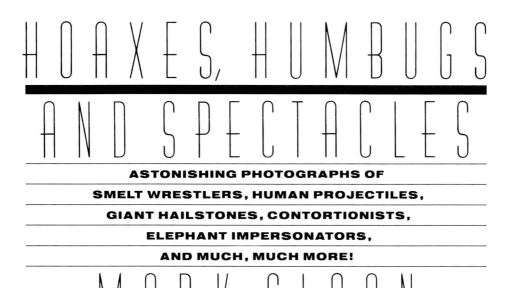 NEW YORK / 1990

Copyright © 1990 by Mark Sloan
Introduction copyright © 1990 by Roy Blount, Jr.
All rights reserved under International and Pan-Amer-
ican Copyright Conventions. Published in the United
States by Villard Books, a division of Random House,
Inc., New York, and simultaneously in Canada by
Random House of Canada Limited, Toronto.

Villard Books is a registered trademark of
Random House, Inc.

A META Museum project

Library of Congress Cataloging-in-Publication Data
Sloan, Mark.
Hoaxes, humbugs, and spectacles: astonishing
photographs of smelt wrestlers, human projectiles,
giant hailstones, contortionists, elephant
impersonators, and much, much more/
by Mark Sloan; with Roger Manley and
Michelle Van Parys.
p.   cm.
Includes bibliographical references.
ISBN 0-394-58511-9
1. Photography—Miscellanea.   I. Manley,
Roger.   II. Van Parys, Michelle.   III. Title.
TR147.s55   1990   779'.092'2—DC20   90-50222
9   8   7   6   5   4   3   2
Designed by J. K. Lambert
First Edition

for Mara

The public is completely uninterested in knowing whether the contest is rigged or not, and rightly so; it abandons itself to the primary virtue of the spectacle, which is to abolish all motives and all consequences: what matters is not what it thinks but what it sees.

Roland Barthes, *Mythologies*

# FOREWORD

## HELL, I'VE SEEN IT DONE
### BY ROY BLOUNT, JR.

What can you say about a picture of 21,000 military men forming a likeness of Woodrow Wilson? In Chillicothe, Ohio.

I don't know.

What do you say *to* 21,000 military men forming a likeness of Woodrow Wilson? "You guys in the ear! One more wiggle and you're cleaning every latrine on this post"?

And what do the men say? Do the ones in the corner of the mouth pass smart remarks about taking one step back so that it looks like Woodrow Wilson is saying "Cheese"?

The time is 1918. Before Armistice Day or after? Possibly no one has told the men that they are forming a likeness of Woodrow Wilson. When I was in the Army, I seldom knew what I was doing. I believe I would have noticed, though, if I'd ever been involved in forming a likeness of Lyndon Johnson. Maybe the key to a true spectacular photograph is that you can't imagine—although you would certainly like to—quite what it was like to be there.

Today of course hoaxes, humbugs, and spectacles are brought into our living rooms, and we are able to interact with video to a greater and greater extent. No doubt walk-around cable service will be with us before long. You'll be able to *wear* a pro football game, people in the streets with these hooded cable jumpsuits on, simulated scrimmage swarming all over them; you'll be able to see the bulges thrashing.

But I'll tell you one thing. I know of no one today who puts on a show to compare

with Thrill Day at the Minnesota State Fair back in the twenties and thirties. Locomotives running into each other! A plane flown intentionally into a house! And afterward you get to go pick up pieces of the wreckage for souvenirs! I would rather see, in person, two locomotives run into each other, than watch or interact with anything on video. I'd rather just *look* at a locomotive.

I would also rather watch Alexandre Patty of Germany doing his stuff. Going down nine stairs on your head is one thing; I've probably done it. But *up* twelve stairs, by way of cranial hops. That must have been something. The only reason I am glad that I wasn't there to watch that performance in 1928 is that I would be so much older today if I had been. On the other hand I would be able to say, as the man said when he was asked whether he believed in infant baptism, "Believe in it? Hell, I've seen it done."

Looking at Herr Patty suspended between stairs, however, makes me feel tense. Is he on his way up? Down? How does he *feel?* Somebody give him some relief!

That picture of Annie Oakley costumed as "Sitting Bull, Jr." (page 19) bothers me, too. I'm glad her outfit won top honors—no one deserves to come home from a ball saying, "I won first prize! Annie Oakley came in second!"—but you wouldn't think Annie Oakley would have felt the need to dress up as somebody else. Not even as late as 1920, when she was sixty and conceivably was tired of her own act. Was Buffalo Bill at the ball, got up as Babe Ruth? Did Sitting Bull (or 21,000 Sioux) come as President Wilson (surely not Jr.)? No, I guess Sitting Bull and Buffalo Bill had passed away by 1920. Annie may have been lonesome. Everyone else at the ball may have been a stiff. She looks resigned.

Most of the other people in these pictures (including, understandably, the Dalton Gang laid out newly dead) manage not to appear too thrilled. Except for the mustache manipulator and a couple of others, most of the performers look matter-of-fact; but you know that behind their expressions lie years of preparation and depths of unusual longing.

I'll tell you who interests me: the kid with his head through the hole in the fence behind the Daltons, best seat in the house. He's not looking at the fresh-shot desperadoes, who lie right in front of him. He's not looking at the camera, either. He seems to be looking at somebody in the crowd behind the camera, and he looks tense. We may suspect that he has found himself living out the old joke—maybe it wasn't old, back then, in 1892—about the boy who said, "Daddy told me not to go to the burlesque show, because I'd see something Daddy didn't want me to see. And I went. And sure enough, I saw something Daddy didn't want me to see. I saw Daddy, right in the front row."

But no, I think he is tense because he is not at all sure how to look, himself, at a spectacle. I think I may know how he feels. Recently my friend Dottie Barkley of Paducah, Kentucky, took me to a funeral home in that city. To see Speedy.

When we entered the home, there was no one around.

"Oh, well," I said, "we'll come back later. These folks are probably—"

"Anybody home?" Dottie called out. "We want to see Speedy!"

"No, that's all right," I said, "these folks don't want—"

Then a perfectly accommodating man came up from the back.

"Yeah, uh-huh," he said, "Speedy right here in the closet."

Speedy was upright, leaning against some furniture, next to a folded-up easel. The man brought him out, and brushed some dust off his head.

"Yeah, Speedy a hundred and twelve years old. He died back in 1928 and he was about fifty then, uh-huh. He was drinking and walked right out in the river and drowned. He didn't have any family, so Mr. Hamock used his embalming fluids on him that he had developed, uh-uh, and kept him around. Back in the sixties the river rose so high till it came in here and floated Speedy right out the window. He was floating along having a terrible time. People thought he was a log. Yeah, uh-huh, Speedy been in the water twice."

"We'd like to take some pictures," said Dottie.

"No, no, that's all right," I said. "We don't really have to—"

"Uh-huh," said the man, "just stand with your arm around him, that's right. Speedy the last one like this. Couldn't do it anymore. Had to get permission from the governor, then. Halloween we put him out front on roller skates, you know, the kids like that. He weighs eighty or ninety pounds, now. Been wearing this tuxedo since he was on *That's Incredible*. Before, he just had on a suit, uh-huh." The man flicked something else off Speedy's forehead. "Yeah, uh-huh, Speedy turning to dust. We going to bury him next year."

I didn't know how to look. In the photograph of Dottie and Speedy, she is smiling as pretty as you please. In the one of Speedy and me, I look like I don't know whether I ought to be doing this. I am striking a defensive attitude, and that spoils the picture.

But I'm glad to have had the experience, and I'm glad to have seen the pictures in this book, and I'm glad that the people in them had the grace to go along with them so unstudiously.

Speedy had little bitty feet that stuck straight down, so that when you held him up he stood on his toes. He had a woody feeling to him. His name was George Atkins.

# PREFACE

This book is the result of several years of picture research in dozens of archives and collections across North America. For me, the research became an inquiry into the nature of human existence—but bringing such an inquiry to completion would, of course, have been impossible. The photographs here represent an ongoing investigation, a small cross-section of a spectacle that is the human spirit—its aspirations and frailties, its triumphs and failures, its grand entertainments and small incongruities, and, perhaps most of all, its sense of fun.

Researching this book presented several unique challenges, the first of which was where to look. My two partners and I visited collections of photographs from Niagara Falls to San Francisco and from Ottawa to New Orleans. (For a full listing of photographic archives, see page 157.) One of the collections consisted of several cardboard boxes kept under their owner's bed. Another was simply a cache of negatives that had never been printed. Most were state and national repositories containing several million carefully catalogued images. And all were potential treasure troves of unknown photographs of unusual or spectacular events. But how to get at that treasure?

None of the archives had a subject heading marked "Human Spectacle." Obviously, we could not look randomly through a million photographs at each archive, so we developed strategies for locating specific types of images. First we would scour the category lists for potentially interesting groupings: "Okay, you take Curiosities and Disasters, and I'll take Contests and Dirigibles . . ." Interesting images came from a variety of different headings. The "Contest" category, for

example, yielded the Frecklesisimograph (page 124). Who would have thought? Each archive had its own methods for categorizing and viewing the photographs, and like layers of an onion, the multiple options as to how an image might be categorized had to be systematically explored. For example, a daredevil's escapades might be listed under daredevils, the name of the daredevil, the location of the event, the store in front of which the event occurred, the newspaper that ran the photograph, the name of the photographer, or the name of the private collection of the daredevil's second wife's sister. As you can imagine, we routinely ran across possible contenders under the oddest, most accidental and inappropriate headings. So serendipity and the I Ching each had a hand in our work.

Once we had located some intriguing images, the next step involved looking through all the photographs we had found, making photocopies of interesting possibilities, and noting any captions or additional information about the making of the image. After visiting all the archives, we compiled our photocopies and began sorting, cogitating, and musing. Eventually, themes began to emerge. Sometimes the same event or performer would be featured in photographs from archives at different ends of the country. Other times an uncanny similarity of event or gesture would appear across a range of otherwise unrelated moments in history. The structure of the book, thematic and idiosyncratic rather than chronological or by archive, gradually suggested itself, almost of its own accord. Serendipity is ubiquitous.

With a preliminary selection of images, our next task was obtaining publishable reproductions. Each archive supplied us with prints (through their photoduplication services) and occasionally they allowed us to make our own copy negatives and prints as well. (We traveled with our own equipment, but generally the prints we collected came from the archives' own print services.) Sometimes the quality of the reproductions was sublime; other times we had to send prints back three or four times to get a really good one. Next came caption and copyright research, and again, we scoured the archives and their indexing systems. In some cases we have reproduced the caption information as it appeared on the original photograph. Where no caption was available, we cross-referenced the images with other sources to come up with our own historical information. Through these avenues we learned things you never learn in school. For instance, before World War II, schoolchildren in the United States pledged their allegiance to the flag with a straight-armed salute (page 94). Hitler's legacy changed all that. And did you ever wonder what B.P.O.E. stood for on the front of the Elks' lodge? Turn to page 98 to find out.

This project took its first breath in 1986 as an idea I had for an exhibition at San Francisco Camerawork Gallery. With the support of the staff and board of directors I took a leave of absence from my curatorial and administrative duties there to research the subject more fully. Curiosity and sheer enjoyment kept me going. I employed the curatorial and picture researching skills of Roger Manley and Michelle Van Parys and we embarked on what was to be the first of several cross-country archive reconnaissance missions. In the spring of 1989 the exhibition opened in San Francisco to an enthusiastic, if perplexed, public. While the exhibition was up, people would frequently say to me, "Oh, you think that's something, well you really have to see the picture of . . . ," leading me to realize the vastness of my subject. As it turned out, the exhibition provided a great many fruitful leads to archives and collections we would later visit. Eventually, in preparation for this book, we combed through more than one hundred individual picture sources over a three-year period. If you add up all of the photographs contained in all the archives we visited, the total is forty-six million. But we saw fewer than half of those up close.

We concentrated on finding images that have never been published or seen outside their native region. Occasional images have appeared in newspapers, magazines, and small-circulation books, but this album is composed largely of unseen and forgotten photographs. Often the images were taken by enthusiastic amateur photographers, but occasionally a professional or press photographer was on the scene. The question of how these photographs ended up in a public archive would be the subject of another book. Suffice it to say that the range of photographs contained in our national, state, and local public repositories is staggering. As a culture, we run the risk of being buried alive in all the images of ourselves that we have created and preserved. The pictures we offer here, then, are literally the tip of a giant "photo-berg"—which swells with millions of images representing nothing less than our collective cultural history as seen by the camera.

MARK SLOAN
*Brasher Falls, New York*

# ACKNOWLEDGMENTS

I would first like to credit a book from my childhood that inspired an interest in hoaxes, humbugs, and spectacles. *One for a Man, Two for a Horse: A Pictorial History, Grave and Comic, of Patent Medicines\** was an ever-present companion when I was young. When I think of the hours I spent poring over the book's illustrations when I could have been outside looking for trouble, I thank the author. I recently found a copy in a used bookstore and realized that I hadn't seen one for twenty years. Flipping through its pages brought back an incredible rush of memories. I identified with its cavalcade of quacks, charlatans, and characters of all stripes. The book's central message is "With the right promotion, you can sell anything." These are words I live by. The Liquozone Company, for example, offered one thousand dollars for any germ that Liquozone wouldn't kill. Needless to say, there are more than a few similarities between the book you are holding and snake oil. And to all of the following people who believed in the importance of this project, I extend a humble thank you and a bottle of Sloan's Liniment.

Alison Acker; Alaiya Aguilar; Lorraine Albano; all friends across the land who provided shelter and provisions for weary researchers; Geoffrey Batchen; John Bloom; Lucinda Bunnen; Brad Bunnin; Tom Burke; Ray Chipault; Janis Donnaud; Tom Fiffer; Peter Gethers; Marnie Gillett; keepers of the Archives; Heather Kilpatrick; J. K. Lambert; Fakir Musafar; Edward Meyer; Wendy Oberlander; John Parker; Olivia Parker; Beth Pearson; the postal workers of Brasher Falls, New

\* by Gerald Carson. Doubleday & Company, Inc.: Garden City, New York, 1961

York; photoduplication laboratory technicians everywhere; RE:Search Publications; SF Camerawork staff and board of directors; Ellen Salwen; Charles Stainback; Chris Sullivan; Jocelyn Thayer; Lyle Tuttle; Jerry Uelsmann.

Special thanks to Roger Manley and Michelle Van Parys, my partners in the META Museum, for their tireless efforts. It was fun. Let's do it again!

I would also like to acknowledge institutional support from the State University of New York, Potsdam, and the Center for Independent Scholars of the Associated Colleges of St. Lawrence Valley, New York.

# CONTENTS

# INTRODUCTION

## CAMERA UBIQUITOUS

One of the many features unique to the medium of photography is its irresistibly democratic nature. Anyone who can point a camera at something is, by definition, a photographer. And it has been this way since photography's invention in 1839. It is no wonder that photography has continued to gain steadily in public popularity. Photographs and photographers are now *everywhere*, a phenomenon of the modern age that's impossible to escape or ignore. The miraculous mass appeal is easy to understand: not only is the technology readily available and easy to operate but photography also has the seductive and unparalleled ability to provide an image that is both fixed in the present and receding into the past.

Despite photography's ubiquity, its written history has concentrated, until now, on the contributions of the so-called "masters" of the medium—their individual innovations, their *oeuvre*, their contribution to photography's "art" history. Most histories of photography are blind to the activities of the ordinary photographer, the snaps of the enthusiastic amateur, the work of small-town photographers and commercial practitioners, and the visual records of those who just happened to be in the right place at the right time. As a consequence, it is unusual to see a book of photographs like this one, organized around a general theme, rather than by photographer, style, or subject. The bulk of the images in this compendium were in fact made by anonymous, unknown, or obscure photographers. Their skill levels range from rank amateur to seasoned professional, but the common thread is a commitment to documenting the astonishing, the unusual, and the spectacular.

Why do we flock to strange and wondrous events, to see the world's smallest

man or the world's longest beard, to witness impossible feats? More to the point, why do we take such pleasure in reliving these moments through the vicarious medium of the photograph?

Here is one possible explanation. Our lives on this earth take many forms and follow divergent paths, but there are certain aspects that could be said to be common, at least to those caught up within Western culture. One of these is the desire to distinguish ourselves from the crowd. The focus of this book, then, is to highlight moments when someone was busy proving a claim to uniqueness. Photography aids this process by "proving" the existence of feats and objects that might otherwise have seemed beyond the realm of possibility. You would not have believed it if you had not seen it yourself in a photograph. Some photographic spectacles, on the other hand, were hoaxes. Can a man really bend an iron bar with his hair (page 20)? Did a mysterious sea monster actually wash up on the beach at Ballard, Washington (page 2)? Some of the rituals, public and private, that are played out on the following pages are a kind of contrived theater. This is something often self-consciously acknowledged by the participants in these photographs. (Note their wry smiles or, even more telling, their mock seriousness.) And this sense of the theatrical extends to the role played in each case by the photographer. There is an arresting, almost uncanny, deadpan quality to these images. Each has been shot head on, without flourish or visual embellishment. The photographer seems to be saying, "Here it is. It really happened and here's the proof."

One interesting aspect of many of these photographs is that, although primarily conceived as "live" events, the photographer's presence was often overtly acknowledged—even becoming the principle focus of attention at times. Today, in an age when the scripted photo opportunity is a political art form and the camera a creator rather than a mere recorder of news, the photographer is someone to be viewed with suspicion. But earlier in this century, the act of photographing, with all its magical connotations, continued to be a spectacle in and of itself. It was a thrill to have one's picture "made." Perhaps this is why there is a strangely static quality to many of these images that belies their dynamic origins. Take, for example, the image of Gust Lessis, the Greek strongman with the stone tablet about to be smashed on his chest (page 105). The blank expressions on the spectators' faces (many of which are turned toward the camera rather than the strongman) and their frozen gestures leave one with an uneasy and unrequited sense of anticipation—a quickening of the heart. The photograph remains engrossing because we will never know what happened when that hammer fell. The people in the picture, however, were around after the shutter clicked. It would be interesting to

know what happened next. Did Gust Lessis withstand the blow? Did they all break for lunch afterward? The possibilities seem endless, with the truth no doubt a little less glamorous than our fertile imaginations would like to admit.

We actually do know a lot about some of these lives. Harry Houdini was one of the undisputed masters of illusion and spectacle, and he was well aware that his eventual place in history would depend largely on the photographs made of his various feats. Whenever possible, he would offer to purchase photographs taken of him by local professionals, the good, the bad, and the ugly—so that *he* could control their dispersion. Houdini thought himself too short (he was five-foot-four), so he devised several protective measures to hide his height from his adoring public. He frequently posed in the foreground with spectators well behind him, thereby using the foreshortening characteristics of the camera's lens to his advantage (page 63). He also often wore a white body stocking and stood above the crowd, thus emphasizing his exalted persona (page 62) rather than his physical imperfections. There were many occasions when Houdini stood on his tiptoes while being photographed with someone taller, not knowing that the shot was full frame. The consummate illusionist was, it seems, especially cagey, though not infallible, when it came to the perpetuation of his own myth.

While Houdini's escapades consisted of carefully prepackaged public spectacles, many of the images in this book are tributes to the small, amusing incongruities of everyday life. These quieter spectacles gain their intrigue from the absurdity of the situations and conjunctions they present. Two photographs illustrate this concept succinctly: "George & Ida Chesworth as The Original Newly Weds: Smallest Perfectly Formed Parents and Modern Ball Room Dancers" (page 34) and "Polygamist Prisoners" (page 90).

"The Daring Ride of Mrs. Eunice Padfield" (page 140) is an achievement that should be part of every history book. This astonishing photograph still leaves the viewer breathless, wondering what the end result could possibly be for Eunice and her horse. Did they do this kind of thing often? Did they both survive? This "Daring Ride" was understandably quite an attraction. So much so that a version of the falling horse act ran continuously at the Steel Pier in Atlantic City, New Jersey, until just a few years ago. Now the only diving horse act is in Lake George, New York—sans Eunice. However, in contrast to the "Daring Ride," many of the amusements and attractions pictured in these pages no longer amuse or attract. Planes crashing into barns and locomotives crashing into each other are pieces of entertainment history that happen now only in the safe confines of Hollywood movies, with stuntmen and special effects. Unions are stronger and public morality

more pronounced. Moreover, risky acts like these are expensive to insure in today's financial climate. So these sorts of larger-than-life spectacles are truly part of a bygone age, but their practitioners live on in images and memories.

The impetus for other types of images arose from attempts to make the world a better place. As these images attest, the more audacious of science's researchers risked life and limb (sometimes their own) to discover the secrets to a longer, healthier, safer life. Mr. Moro (page 130) is pictured performing an early cryogenic experiment in which he himself was "successfully" frozen in a block of ice. Similarly, Professor Edward G. Wilkinson demonstrated a new technique for "Burning Out Neuralgia" (page 127) that looks like a scene from a science fiction movie. In "Cops Test Bulletproof Vest on Inventors" (page 120), inventor Jack Schuster stands safely by while his assistant is put to the ultimate test. These forays into the technological unknown prove the resilience, ingenuity, curiosity, and occasional foolhardiness of the human spirit. The fact that a photographer is present in each case also suggests an awareness of the potential entertainment and perhaps commercial value of unusual scientific demonstrations.

One of the major genres that emerged during the making of this collection was our fascination with flight. Anything involving defying gravity has always been a surefire crowd gatherer. From the myth of young Icarus and his fatally close encounter with the sun, our preoccupation with flight and leaving the bounds of the earth has led to some interesting performances and achievements. Once the airplane was invented, it was not long before men and women were using it as a platform from which to attempt feats even more death-defying than air travel itself. Lillian Boyer (page 54), Lincoln Beachey (page 144), and Jersey Ringel (page 154) are in the pantheon of airborn daredevils following the Wright Brothers.

These are just a few of the images and themes that appear in the pages of this book. There is no one history being presented here, but rather a series of signposts to many possible histories and many other signposts, too.

A NOTE ABOUT THE ARCHIVES: The individual photographs selected for this volume all share a common heritage: they sprang from existing archives or large collections. In many cases not only are the incidents and the subjects long forgotten, but also the photos themselves. As it happens, the archives and collections in which these photographs were found are cultural storehouses that contain vast quantities of images and unprocessed information. This "raw data" is positively ripe with potential, and yet it lies quietly in musty back rooms, waiting for eager eyes and minds to release it. We are indeed fortunate and privileged that recorded

images such as the ones in this book have been stored and preserved. However, more must be done to make these pivotal moments in history part of our current culture. As a society, we continue to funnel our collective histories into these institutions where, save for an occasional scholarly article or two, they are systematically ignored. We now have supply-side archives with virtually no demand, except for the continuing mandate to collect and preserve. This book, though no more than one idiosyncratic slice through the available material, should be taken as a call to renew our interest in these archives and celebrate the forgotten triumphs and struggles, the hoaxes, humbugs, and spectacles of the human spirit.

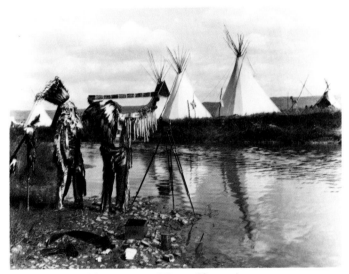

*(Dr. Joseph Kossuth Dixon; courtesy Library of Congress)*

# HOAXES AND HUMBUGS

**Never let the truth**

**stand in the way of a good story.**

Anonymous

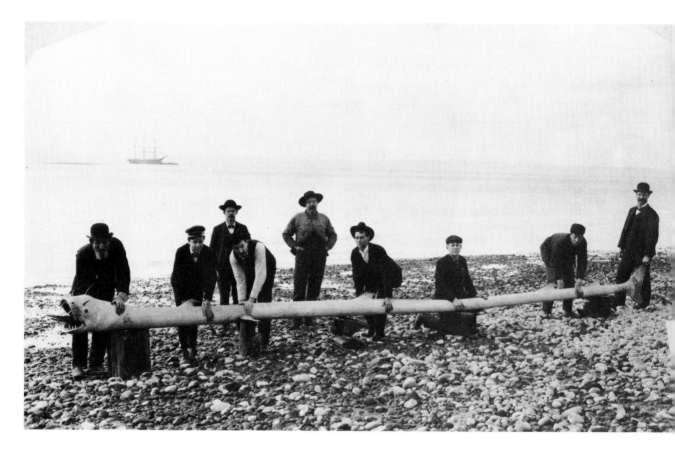

**SEA MONSTER (1906)**

It took seven strong men to drag this enormous Pacific sea serpent along the beach at Ballard, Washington. Its biological origin remains a mystery.

*(W. M. Horton & N. R. Davis; courtesy Library of Congress)*

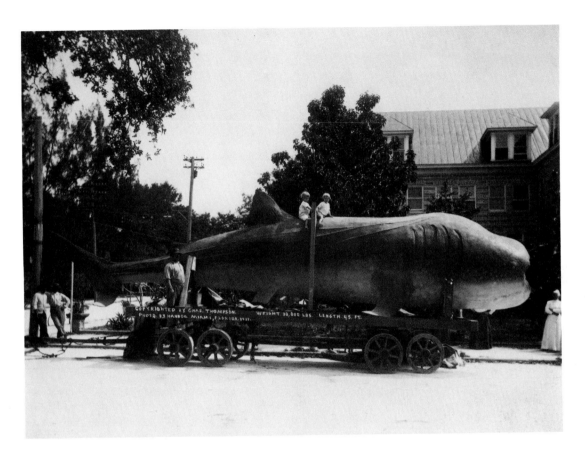

**FISH STORY (1913)**

In Miami in 1913 a giant shark, tipping the scales at a whopping 30,000 pounds, was captured and trundled around the city as a traveling display. Sometimes it was accompanied by comparatively Lilliputian riders, who were not a permanent part of the act.

*(Hand; courtesy Library of Congress)*

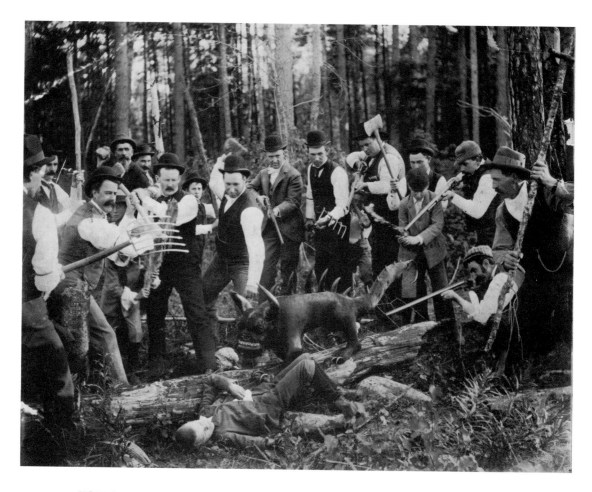

### HODAG HUNT (circa 1930)

Called *Bovine spirituallis*, the "hodag" featured a bull's head, a man's grimacing face, short legs with strong claws, a dinosaur's back, and a serpent's tail with a spear at the end. It was discovered by E. S. Shepard and two companions near the headwaters of Rice Creek, Rhinelander, Wisconsin. The beast was described in the *Rhinelander Daily News* as "the long-sought missing link between the ichthyosaurus and the mylodoan" of the Ice Age. After its "capture" it was exhibited in dim light to visitors who could not tell that it was a large dog with a decorated horse's hide stretched over it. ("Hodag" is a combination of "horse" and "dog.")
*(Courtesy State Historical Society of Wisconsin)*

*A humbug takes an old truth and puts it in an attractive form.* —P. T. Barnum

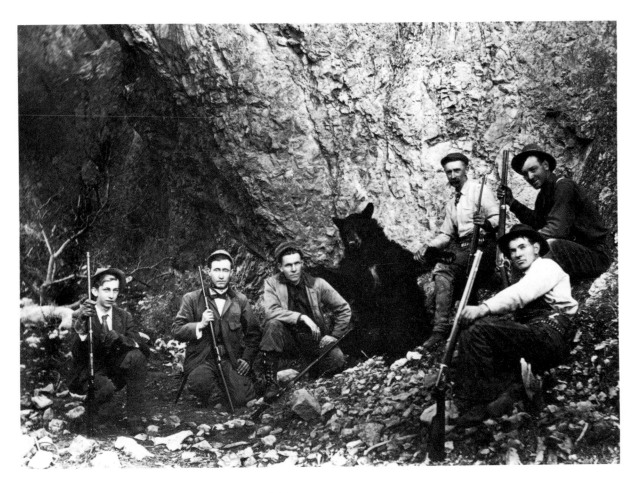

**THE GANG'S ALL HERE (circa 1900)**

After a long day of playing cat and mouse in the Utah wilderness, this large bear
struck a studied pose and joined its hunters for a group portrait.

*(Courtesy Utah State Historical Society)*

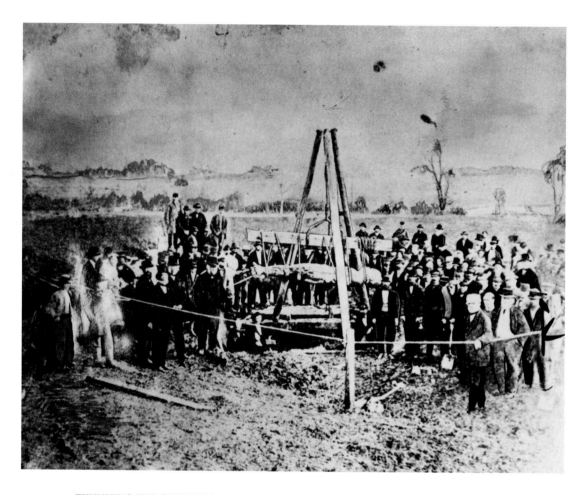

### EXHUMING THE CARDIFF GIANT (1869)

On October 16, 1869, two hired hands were digging a well near Cardiff, New York, and uncovered a "giant" measuring 10 feet 4 inches—one of the greatest hoaxes of all time. George Hull, the perpetrator of this grand humbug, had contracted two sculptors and supplied them with beer as they carved. Their original design called for hair and a beard, but after Hull discovered that hair does not petrify, off it came.

Hull buried the giant, then waited a year before hiring the well diggers to go out and "discover" it. Crowds began amassing almost immediately, and soon a tent was set up and admission charged for a peek. The Giant was such a sensation it actually received votes for public office, and newspaper and magazine articles debating its authenticity were rampant. By December 1869, it was proven conclusively that the Giant was a hoax, but curiously this did not slow interest. In 1948 the Giant was reinterred at the Farmers' Museum, where visitors can still see it.

*(C. O. Gott; courtesy New York State Historical Association)*

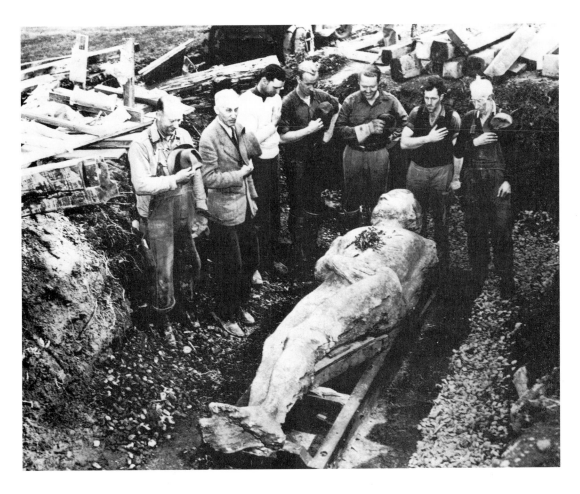

**THE CARDIFF GIANT LAID TO REST AT THE FARMERS' MUSEUM, COOPERSTOWN, NEW YORK (1948)**
*(Courtesy New York State Historical Association)*

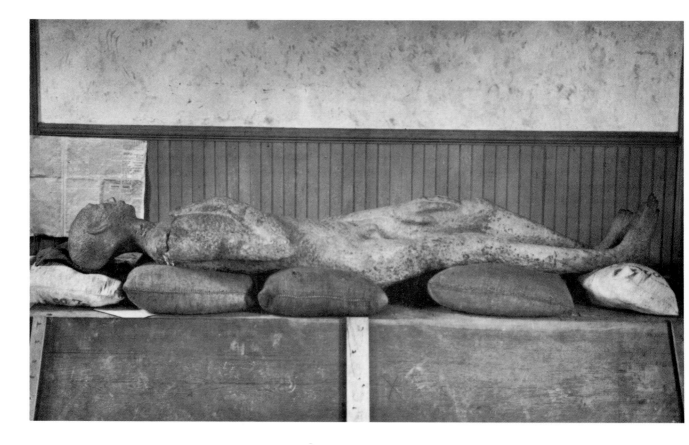

### THE SOLID MULDOON—THE MISSING LINK (1877)

Fast on the heels of his Cardiff success, George Hull embarked on a new scheme.
He hired a Mr. Fitch, who had patented "Portland Cement," to create a new giant
that would measure 7 feet 5 inches, weigh 600 pounds, and possess a four-inch tail.
To fool scientists, they embedded bones from a human skeleton in the concrete,
then added a cow's shinbone to the neck for reinforcement.

During his Cardiff days, Hull had spurned a sixty-thousand-dollar offer from P. T.
Barnum to lease the Giant, but now, having sacrificed his life's savings to the Solid
Muldoon, he approached Barnum. Barnum sent a scout, a second "discovery"
ensued, and when interviewed, Barnum commented: "Well, sir, it is my candid
opinion that in this discovery we have found the missing link which Darwin claims
connects mankind with beast creation."

The Solid Muldoon was shipped to Barnum's New York Museum of Anatomy,
where "scientists" were to examine it. In an ending even Barnum could not have
imagined, Fitch fessed up to the hoax—just as they were ready to cross-section the
stomach.

*(Thurlow; courtesy Colorado Historical Society)*

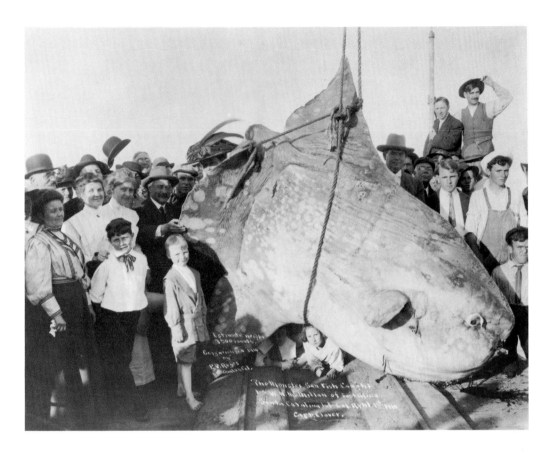

**MONSTER SUNFISH AND DWARF (April 1, 1910)**

A prank for posterity, or a fisherman's dream? The date is an auspicious one for tricksters, but to be fair to W. N. McMillan, the angler credited with this catch, there have been sightings of very large sunfish. Perhaps the lesson to be learned is: If you catch a big fish, don't do it on April Fools' Day.

*(P. V. Reyes; courtesy Library of Congress)*

# SPECTACLES

---

**Human affairs are like a chess game:**

---

**only those who do not take it seriously**

---

**can be considered good players.**

Hung Tzu-ch'eng

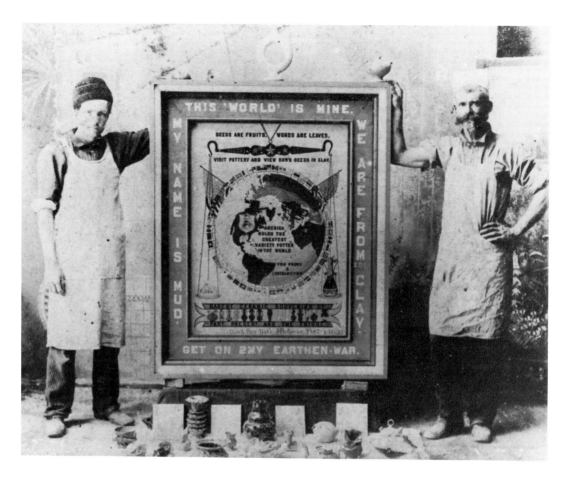

**HANDS OF CLAY (circa 1920)**

George E. Ohr, at right, posing humorously with his assistant. Ohr, a resident of Biloxi, Mississippi, billed himself as "The Greatest Variety Potter in the World (You Prove a Contradiction)" and described his works as "The Rarest Ceramic Souvenirs of Past, Present, and Future." A lifelong eccentric, Ohr experimented with trick photography, sculpture, costume design, and mustache manipulation (captured in the pictures opposite) in addition to creating his pottery masterpieces, which earned him the sobriquet "Mad Potter of the Mississippi Mud."
*(Courtesy Mississippi Department of Archives and History)*

*The only way to get rid of a temptation is to yield to it.* —Oscar Wilde

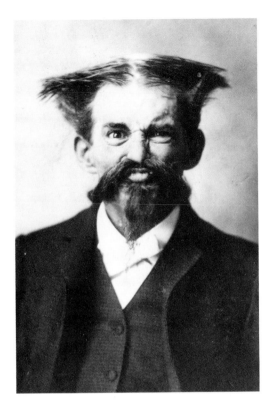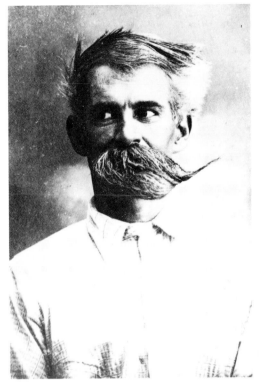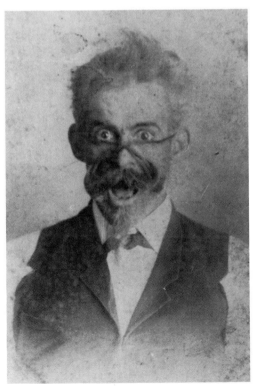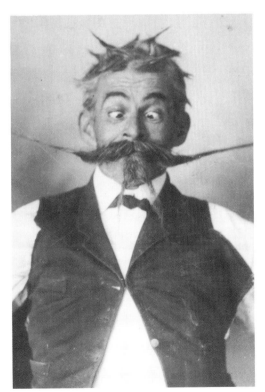

 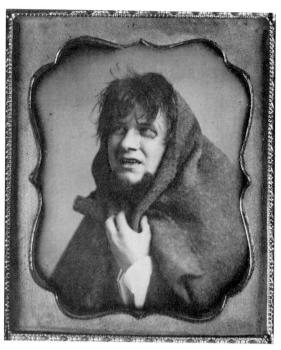

### THE PASSION SERIES (circa 1852)

Montgomery Pike Simmons was born in 1817 and began making daguerreotypes in
the mid-1840s in Philadelphia. In 1852 he opened a gallery in Richmond, Virginia,
which he operated until 1856. "The Passion Series" was instigated by artist William
J. Hubard and Mann S. Valentine II, a Richmond businessman and founder of the
Valentine Museum. The thirty daguerreotypes in this series, taken around 1852,
used both Hubard and Valentine as models. As the name "The Passion Series"
suggests, the photographs were intended to illustrate the range of facial expressions
found in humans. They are among the earliest examples of people performing for the
camera, and it is possible that Hubard used these images as studies for his
art as well.

*(From the exhibition* Mirror of an Era: The Daguerreotype in Virginia. *organized by the Chrysler Museum,
Norfolk, Virginia; courtesy the Valentine Museum, Richmond, Virginia.)*

*Nothing is so curious and thirsty after knowledge of dark and obscure matters as the
nature of man.* —Thomas Wright, from *The Passions of the Mind in General,* 1601

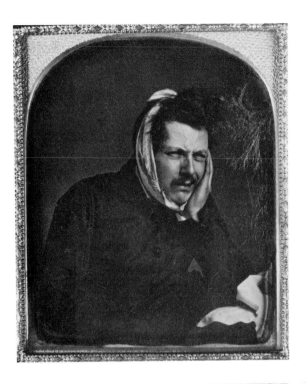
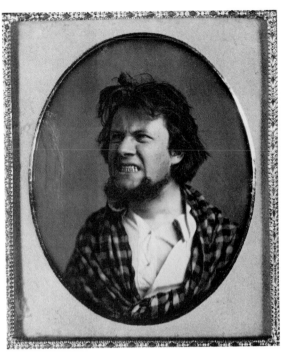
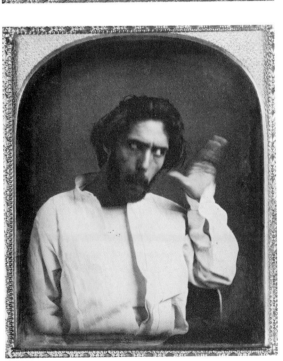
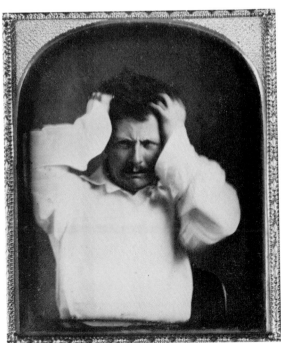

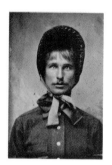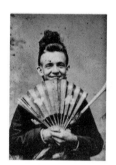

**MEN IN WOMEN'S CLOTHING (circa 1863)**

Tintypes were very popular between 1856 and 1930. Quite often, itinerant photographers, such as Walter Collins, would travel around and set up tent studios at county fairs, making keepsake photographs like the ones shown above. The photographs are printed in their actual size.

The tintype process involved coating a tin plate with emulsion and then exposing it directly in the camera. The tin plate itself then became the actual picture. Tintypes sold for a few cents each.

*(Walter A. Collins Collection; courtesy Colorado Historical Society)*

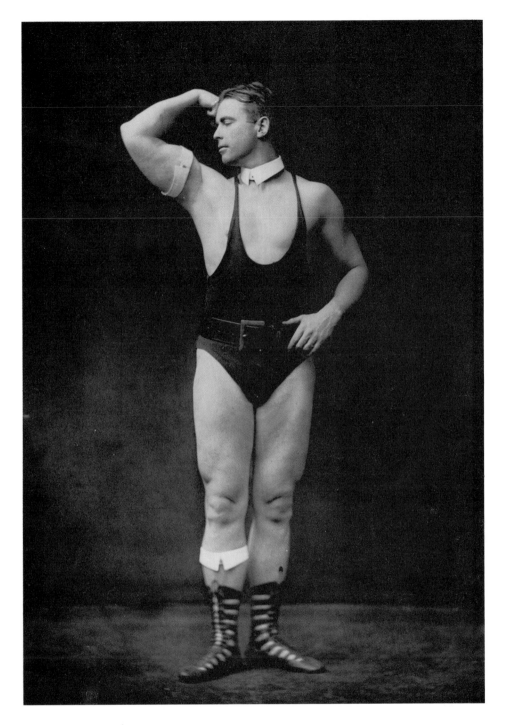

**IDEAL MAN (circa 1933)**

This paragon of perfect manhood posed wearing three size 16 collars around his neck, bicep, and calf.

*(C. S. Schlitzer; courtesy RIPLEY'S BELIEVE IT OR NOT!®)*

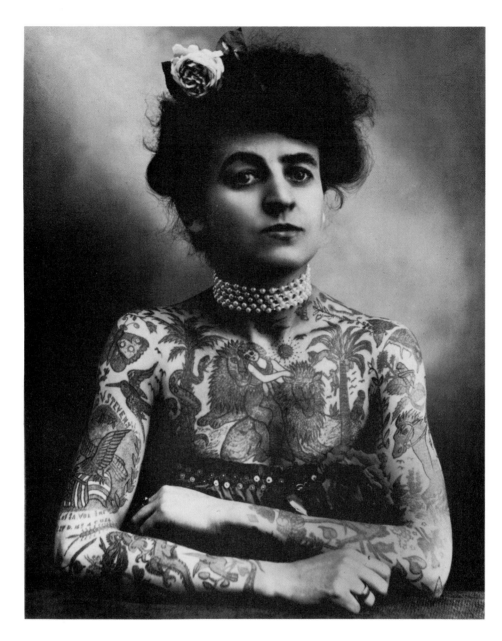

**MRS. MAUD STEVENS WAGNER (circa 1912)**

Maud Stevens was 32 years old when she appeared as an aerialist at the 1904 St. Louis World's Fair. There she got her first tattoo and met the Tattooed Globetrotter, Gus Wagner. They fell in love and married during the fair. When the fair closed, she left the troupe of flyers and traveled with her colorful husband, one of the last tattooists who continued to work by hand. Gus tattooed his wife and taught her his art, and the two traveled together from coast to coast. Maud was last heard of tattooing, still by hand, during World War II in Junction City, Kansas, with her daughter. But what ever happened to Gus?

*(Courtesy Library of Congress)*

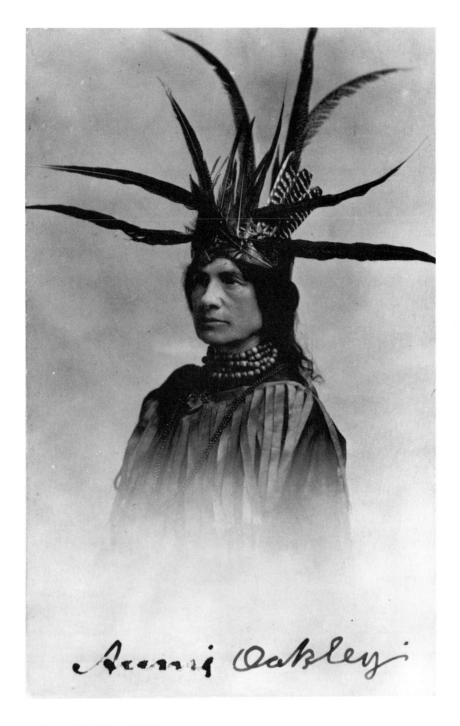

*Annie Oakley*

**FIRST PRIZE (circa 1920)**

Annie Oakley, famed markswoman of Buffalo Bill's traveling Wild West Show, appeared at a costume ball at the Carolina Hotel in Pinehurst, North Carolina, as "Sitting Bull, Jr." She was awarded first prize for best costume.

*(Courtesy Garst Museum, Greenville, Ohio)*

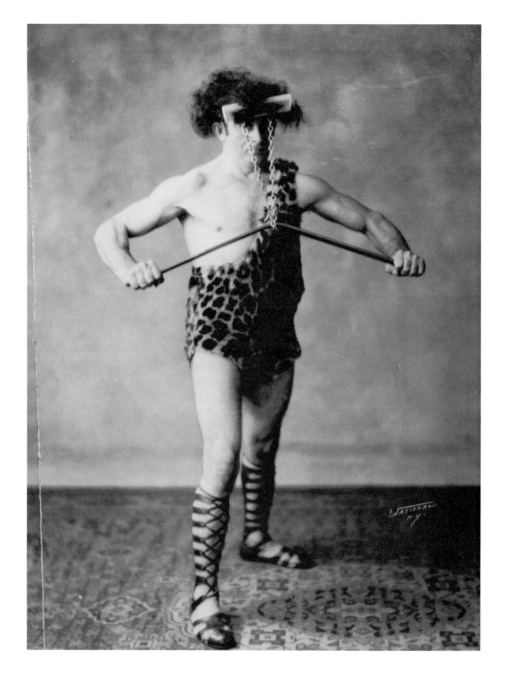

**THE MIGHTY ATOM (circa 1931)**

Joseph Green (real name Joseph Greenstein), "The Mighty Atom," was
photographed here doing his famous stunt: bending an iron bar with his hair. Green
was five-foot-five and weighed 148 pounds, and could pull as much as 21,000 pounds
—the equivalent of three cars—with his hair.

*(National Studios; courtesy RIPLEY'S BELIEVE IT OR NOT!®)*

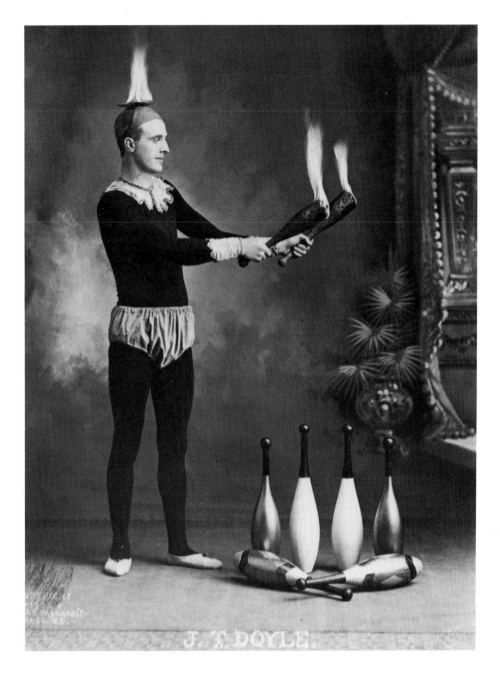

**HUMAN TORCH JUGGLER (1902)**

How this performer managed to keep a cool head is anybody's guess.

*(J. E. Pasonault; courtesy Library of Congress)*

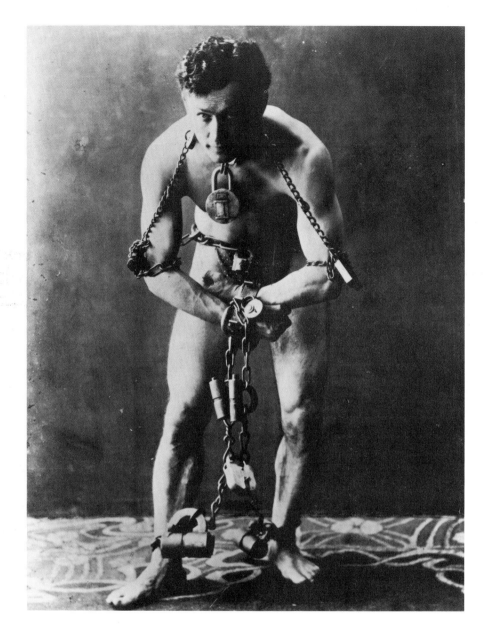

**HARRY HOUDINI, KING OF HANDCUFFS (1920)**

Houdini, the tireless promoter, posed for this picture as part of his publicity efforts.

*Where the possibility ceases, The impossibility commences!*
*Harry Houdini*
*"KING OF HANDCUFFS"*

Positively *the only conjurer in the* world *that escapes out of all handcuffs, leg shackles, insane belts and straitjackets, after being stripped STARK NAKED, mouth sealed up, and thoroughly searched from head to foot, proving he carries no keys, springs, wires or concealed accessories.*

*(Courtesy Houdini Magical Hall of Fame)*

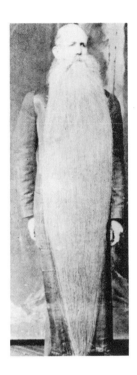

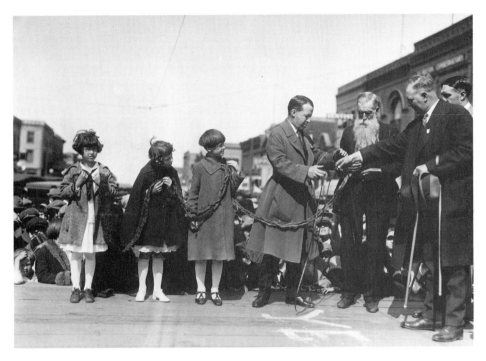

## A HAIR'S-BREADTH

What do Penland, North Carolina, and Breckenridge, Minnesota, have in common? Both have boasted a man who claimed to have the world's longest whiskers. Mayor Leach of Breckenridge looped his illustrious citizen's beard over the arms of schoolgirls in 1935 for a grand public measuring; in Penland in 1921 the beard was brushed and its owner posed for a formal portrait. No one knows for sure which of these two gentlemen had the world's longest whiskers, but each had his day in the sun.

*(Left: Courtesy Minnesota Historical Society; right: Courtesy North Carolina Collection, University of North Carolina Library at Chapel Hill)*

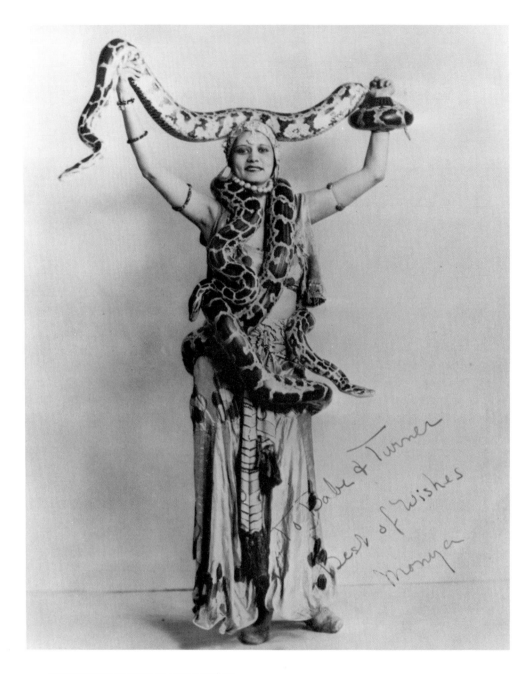

**MONYA WITH SNAKES (circa 1930)**

Monya picked up where Eve left off.

*(Courtesy Utah State Historical Society)*

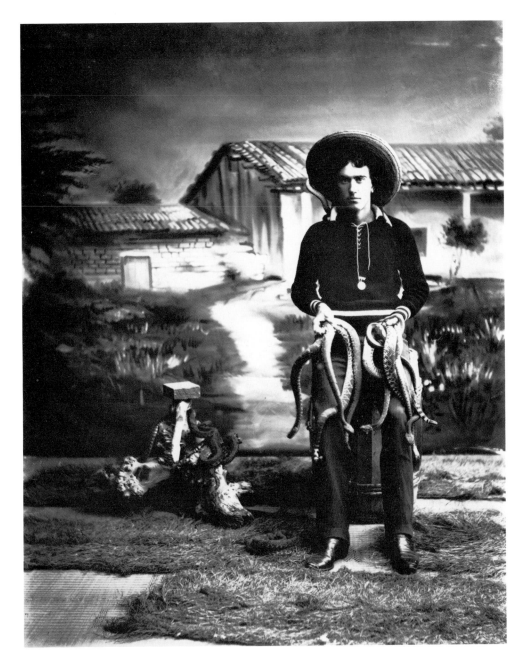

**SNAKE CHARMER (circa 1900)**

This turn-of-the-century cowboy displayed the results of a rattlesnake roundup.

*(Courtesy California State Library)*

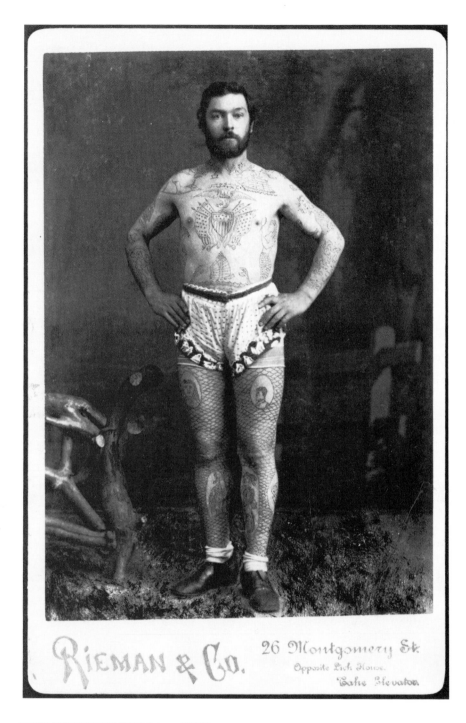

**THE ILLUSTRATED MAN (circa 1880)**
*(Rieman and Company, San Francisco; courtesy California State Library)*

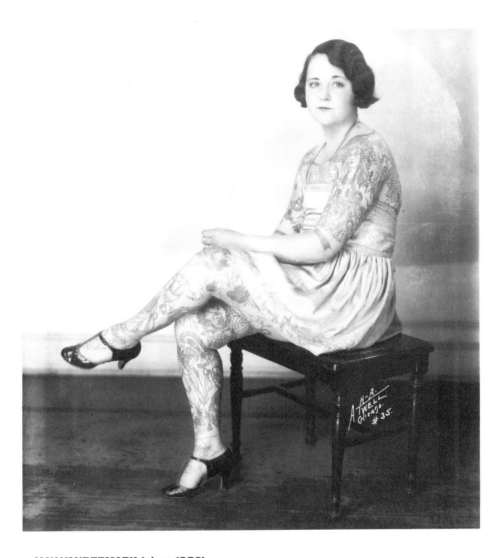

**MAY VANDERMARK (circa 1930)**
*(H. A. Atwell; courtesy Circus World Museum, Baraboo, Wisconsin)*

*Tattoos have always been associated with travelers and seafarers. Jack London said,
"Follow any man with a tattoo and you will find a romantic and adventurous past."
This is why the tattooed man or woman was such a great attraction in the circus and
later carnival sideshows.*

*Tattooed people have gone on display in Europe for centuries, dating back to
Prince Jeoly, a South Seas island native brought to England in 1691 by Captain
William Dampier. Jeoly toured the country and became a star immediately. This
started a new fad, helped increase the interest in one of man's oldest art forms, and
started a new profession, the tattooed attraction, which provided thousands of people
a livelihood for three hundred years.*

*Tattooing is more popular today than at any other time in history. But the tattooed
attraction is now a thing of the past. Mostly, the traveling sideshow has all but
disappeared and heavily tattooed people are now not a rarity.* —Lyle Tuttle,
founder and director of the Tattoo Art Museum, San Francisco

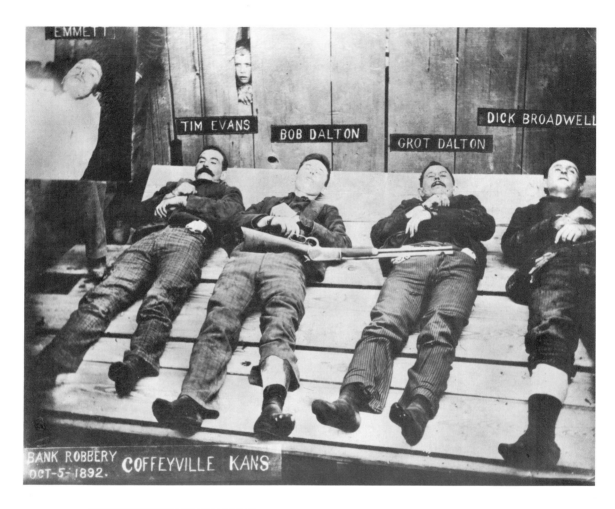

### DALTON GANG LAID OUT (1892)

On October 5, 1892, the Dalton Gang returned to Coffeyville, Kansas. Their plan
was to rob the Condon Bank and the First National Bank of Coffeyville
simultaneously and thereby become the most notorious bank robbers of all time. But
the gang did itself in. Within fifteen minutes, four citizens were dead, along with the
four gang members pictured here. Emmett Dalton was wounded but survived, and
his picture, taken in the hospital, was later collaged onto this print. Many people
paid for these pictures to have proof that the dangerous Daltons were actually dead.

*(Tackett; courtesy Kansas State Historical Society)*

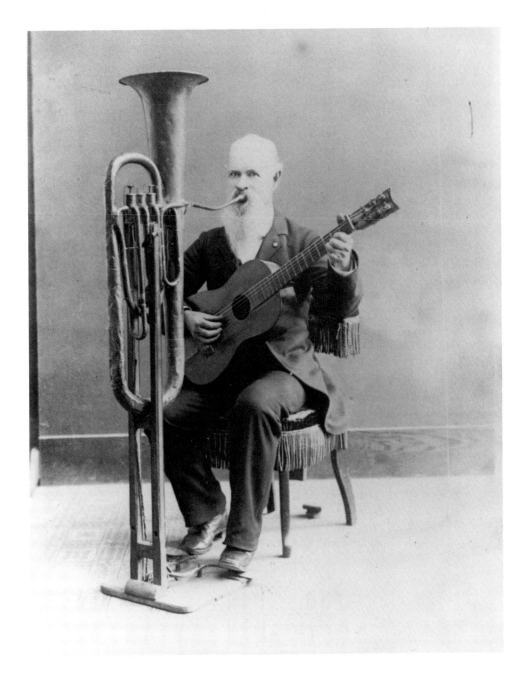

**ONE-MAN BAND (circa 1890)**

Charles Wallace Jacob Johnson—miner, photographer, musician, dance instructor
—with his musical "one-man band" invention.

*(Courtesy California State Library)*

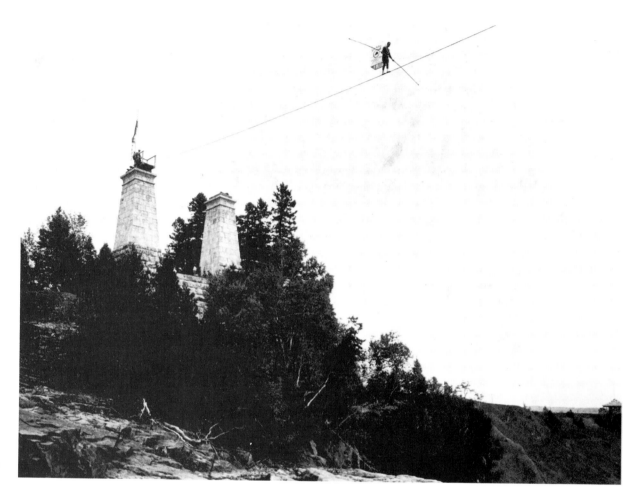

### BALANCING BILLBOARD (1903)

James E. Hardy was an aerialist who developed an unusual professional specialty: carrying advertisements, such as this oversized cigarette pack, on his back while balanced on a high wire. Here he is, crossing Montmorency Falls in Quebec. His publicist was immodest on his behalf:

> *A Furor at the Principal Parks, Fairs, Exhibitions*
> *and Celebrations in Europe and America.*
> *Unequalled in Originality and Unsurpassed in Novelty.*
> *A Positive Sensation. The Most Astounding and*
> *Amazing Aerial Exhibition Human Eyes Ever Beheld.*

*(Courtesy Niagara Falls Museum)*

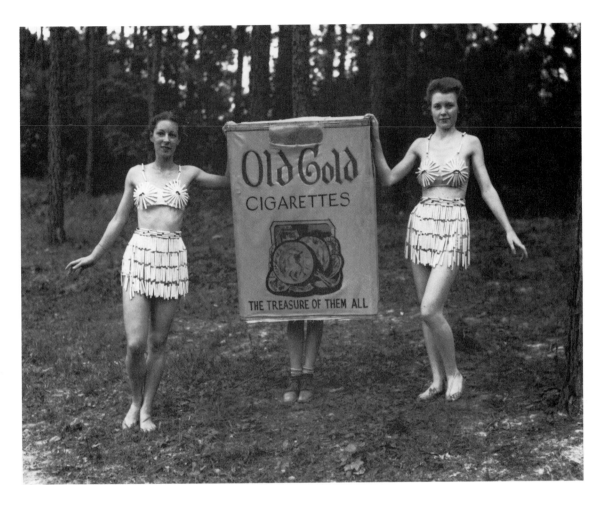

**OLD GOLD (circa 1930)**

Margaret Strickland and Hallie Hubbard lit up the National Tobacco Festival in
South Boston, Virginia, when they wore these costumes made from cigarettes.

*(Virginia State Chamber of Commerce; courtesy Virginia State Library and Archives)*

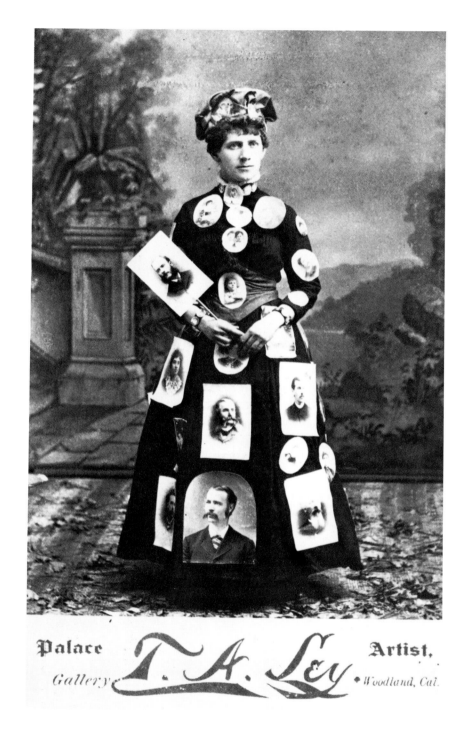

Palace Gallery *T. A. Ley* Artist, Woodland, Cal.

**MRS. T. A. LEY (circa 1890)**

T. A. Ley owned a photo studio in Woodland, California, and for this publicity
photo his wife adorned herself with his work.

*(Courtesy California State Library)*

# GIANTS, DWARFS AND SIAMESE TWINS

Our senses can grasp nothing that is extreme. Too much noise deafens us; too much light blinds us; too far or too near prevents us seeing; too long or too short is beyond understanding; too much truth stuns us.

Blaise Pascal, 1670

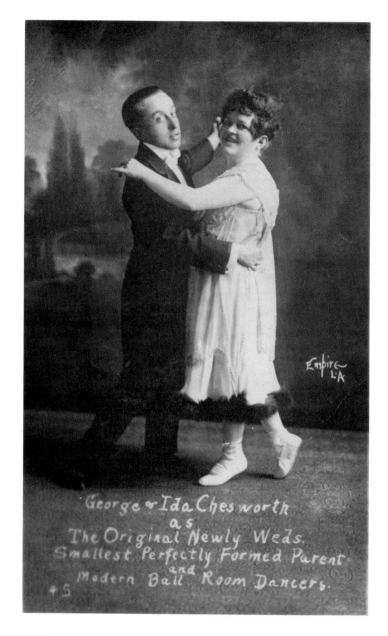

**LIGHT ON THEIR FEET (circa 1925)**

In this publicity photo, George and Ida Chesworth billed themselves in a big way, making the triple claim of being the Original Newlyweds, the Smallest Perfectly Formed Parents and Modern Ballroom Dancers.

*(Empire Studios; author's collection)*

*A marriage makes of two fractional lives a whole; it gives to two purposeless lives a work, and doubles the strength of each to perform it; it gives to two questioning natures a reason for living, and something to live for; it will give a new gladness to the sunshine, a new fragrance to the flowers, a new beauty to the earth, and a new mystery to life.* —Mark Twain

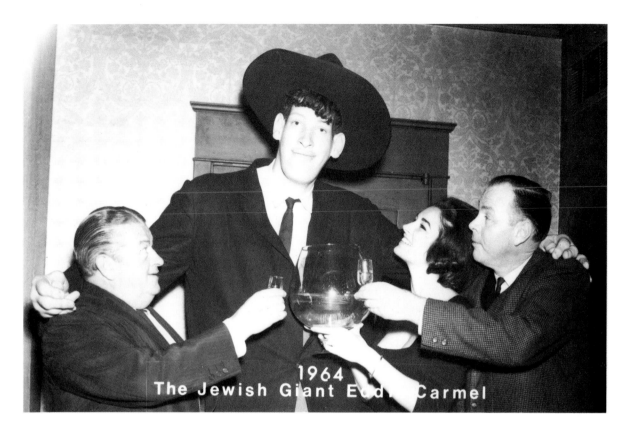

1964
The Jewish Giant Eddie Carmel

**EDDIE CARMEL—THE JEWISH GIANT (1964)**

Eddie claimed to be 9 feet, ⅝ inch (weight 535 pounds), but his actual height was
7 feet, 7 inches. Very big and very small people on the circuit commonly
exaggerated their size (up or down)—anything for a bigger crowd. Born in 1938 of
parents of normal height in Tel Aviv, Israel, Carmel toured with Ringling Brothers
and Barnum & Bailey and was billed as "The Tallest Man on Earth." Many will
recognize him as the subject of a family portrait by Diane Arbus titled *Jewish Giant
in the Bronx*.

*(Author's collection)*

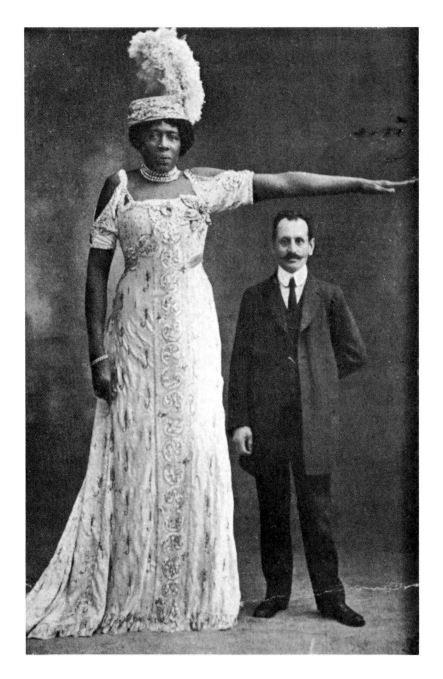

**ABOMAH THE AFRICAN GIANTESS (circa 1920)**

Circus and sideshow performers often supplemented their earnings by selling souvenir pictures to the crowd after a show. In this photo, Abomah the African Giantess is seen with a man who doesn't quite measure up.

*(Author's collection)*

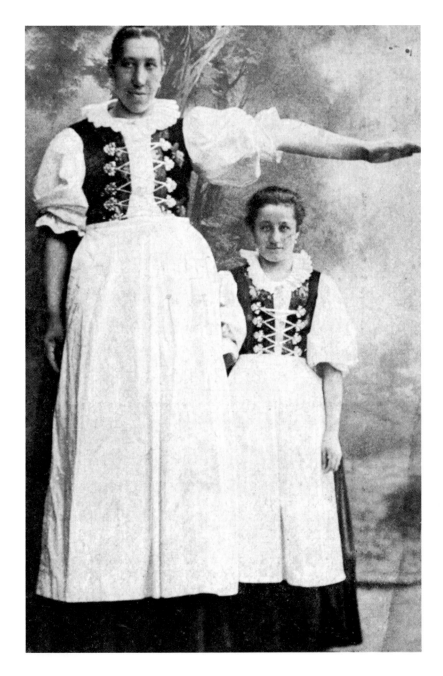

**MARIEDL—THE TYROLEAN GIANTESS (circa 1920)**

This souvenir picture features Mariedl, The Tyrolean Giantess, and a woman
dressed similarly for size comparison. At age 27, Mariedl weighed 360 pounds, and
her daily diet included, among other things, 14 pounds of cereals and vegetables.
Despite the skirt, ruffled sleeves, and frilly collar, suspicion arose that Mariedl was
actually a man.

*(Author's collection)*

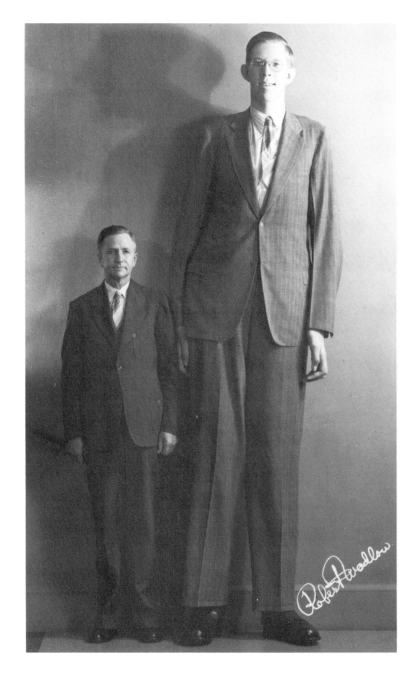

**FILLING HIS FATHER'S SHOES . . . AND THEN SOME (circa 1940)**

According to the *Guinness Book of World Records*, Robert Wadlow was the world's largest human. Pictured here next to his father, the mayor of Alton, Illinois, Wadlow reached a height of 8 feet, 11.1 inches, and a weight of 491 pounds before his death at age 22 in 1940. His abnormal growth began after a double hernia operation at the age of two.

*(Author's collection)*

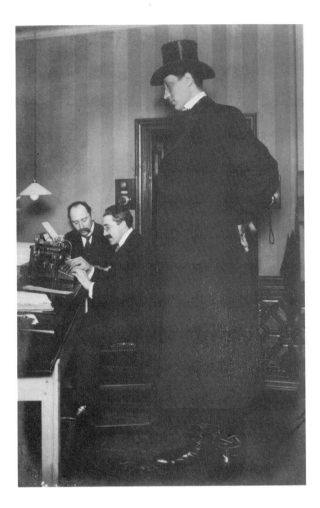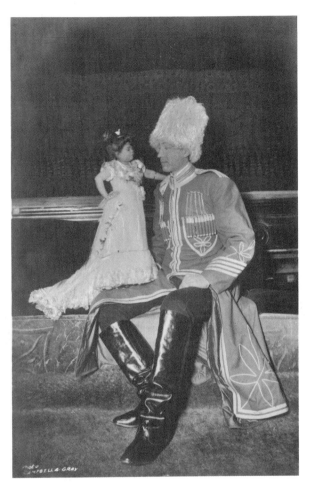

**THE RUSSIAN GIANT MACHNOW AT THE LONDON HIPPODROME (1905)**

These two pictures illustrate another ploy commonly used by clever promoters—making the giant appear to be "one of us." Here we see Machnow (who claimed to be 9 feet 4 inches in his stocking feet) performing the unspectacular act of dictating letters, yet the contrast of his size with his activity is unsettling. He also thrilled London crowds by donning a Cossack's uniform (sewn especially for the occasion) and chatting with Chiquita (who measured a Lilliputian 2 feet 4 inches), resplendent in ballroom regalia.

*(Campbell & Gray; author's collection)*

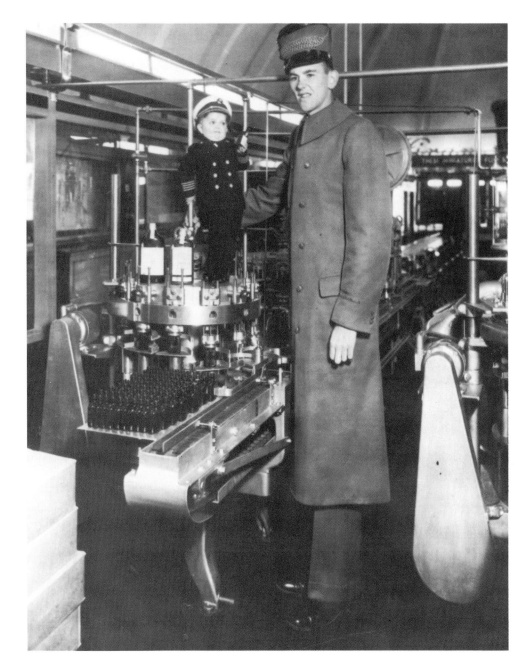

**SMALLEST AND TALLEST (1933)**

Captain Werner Ritter, age 21, was then the smallest man in the world at 18 inches tall and weighing 19¾ pounds. Captain Gilbert Reichert, age 19, was more than 8 feet tall and weighed 265 pounds. This photograph was taken in the world's smallest distillery at Chicago's Century of Progress Exhibition.

*(Underwood and Underwood; courtesy Underwood Photo Archives, San Francisco)*

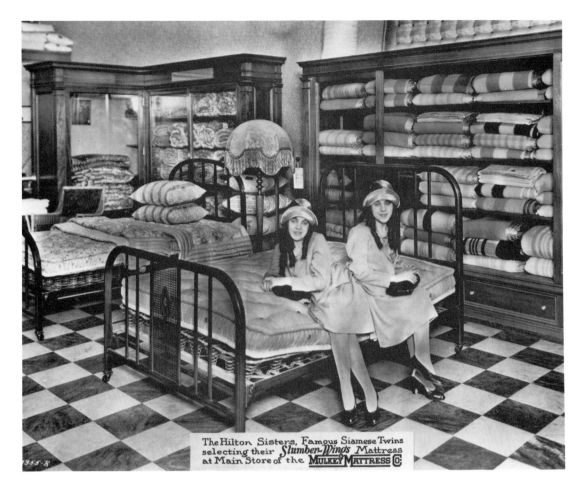

The Hilton Sisters, Famous Siamese Twins selecting their *Slumber-Wings* Mattress at Main Store of the MULKEY MATTRESS CO.

## TWIN BED (circa 1926)

Born in England in 1908, Violet and Daisy Hilton were perhaps the most successful of all Siamese twins. In 1913 they were sold to a nurse who then sent them to Australia to go on exhibition. In 1916 they were brought to the United States, where they were educated. Both sisters were very musical, playing piano and violin, and by 1926 they had become popular entertainers on the vaudeville circuit, earning as much as five thousand dollars per week, most of which was stolen by their unscrupulous manager. At the height of their extraordinary career they lived in a house in San Antonio, Texas, designed for them by Frank Lloyd Wright.

After retiring to Miami Beach in 1955, where they opened a snack bar, the twins moved to a small white frame house in Charlotte, North Carolina, and took jobs as checkout girls in the Pick-n-Save grocery store. Late in life they shunned publicity, but they did make one brief appearance in 1964 as an "added attraction" at a drive-in screening of *Freaks*. Their film biography, in which they starred, was called *Chained for Life*.

The twins died on January 4, 1969, at their home in Charlotte. Violet had been ill with the flu.

*(Ford E. Samuel; courtesy Underwood Photo Archives, San Francisco)*

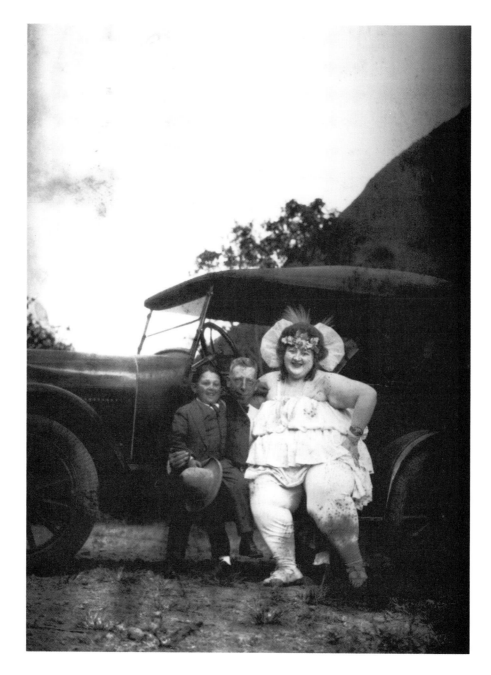

**SUNDAY OUTING (1924)**

The Fat Lady, a dwarf, and their manager take time to pose in Honolulu, Hawaii, where they were performing at the Elks Mid-Winter Carnival.

*(Courtesy Ellen Salwen Collection)*

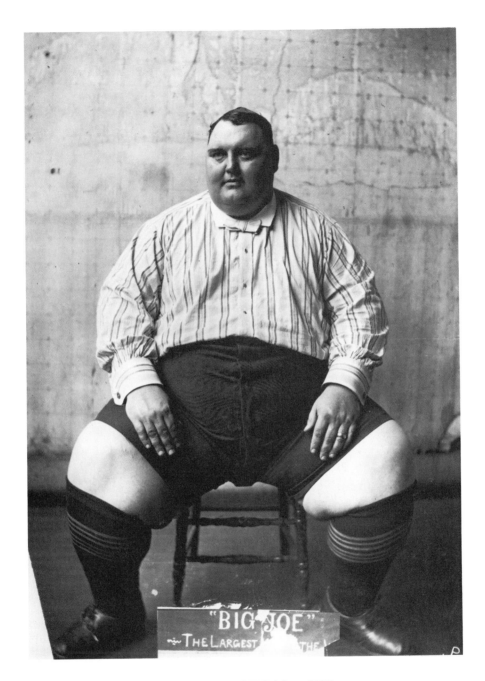

**BIG JOE—THE LARGEST MAN IN THE WORLD (circa 1910)**

Fat people, such as Big Joe, usually appeared in circuses as sideshow performers, who were considered a separate attraction from the main event. Along with the actual circus performers—clowns, jugglers, acrobats—the sideshow and the menagerie (the animals) made the circus complete. Many sideshow performers traveled at different times with rival circuses, making a living as free-lance freaks.

*(Courtesy Library of Congress)*

# DAREDEVILS AND
# FLIRTS WITH
# DEATH

By daring, great fears are concealed.

Lucan, 65 B.C.

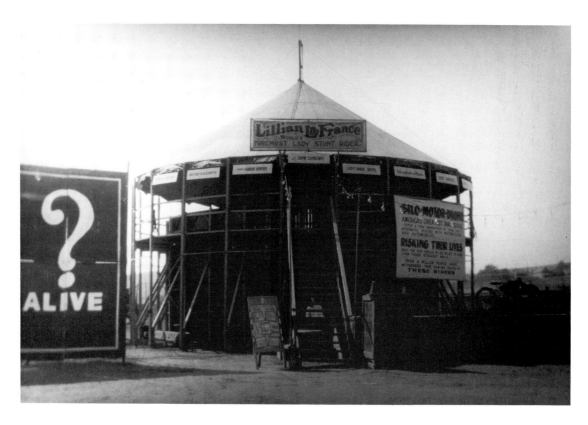

**LILLIAN LAFRANCE'S SILO-MOTOR-DROME—"THE WALL OF DEATH" (circa 1925)**

Lillian LaFrance (real name, Lillian Ossage) was an extraordinary motorcycle daredevil active during the 1920s and 1930s. She was billed variously as "The Girl Who Flirts with Death" and "The World's Foremost Lady Daredevil." Her Motor-Drome troupe traveled extensively around the Pacific Rim, concentrating on California, but performing in Tokyo, Burma, Hawaii, and Mexico City as well. The troupe set up the "Wall of Death" at each location. Lillian's performing costumes often were adorned with a skull and crossbones or a pair of "lucky seven" dice.

*(Courtesy Ellen Salwen Collection)*

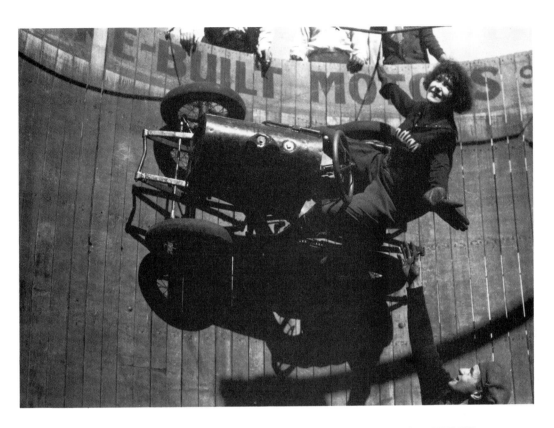

**LILLIAN RIDING THE WALL OF DEATH IN HER STUNT CAR, WITH NO HANDS ON THE WHEEL, AND DISPLAYING BROKEN DIGIT (circa 1925)**
*(Courtesy Ellen Salwen Collection)*

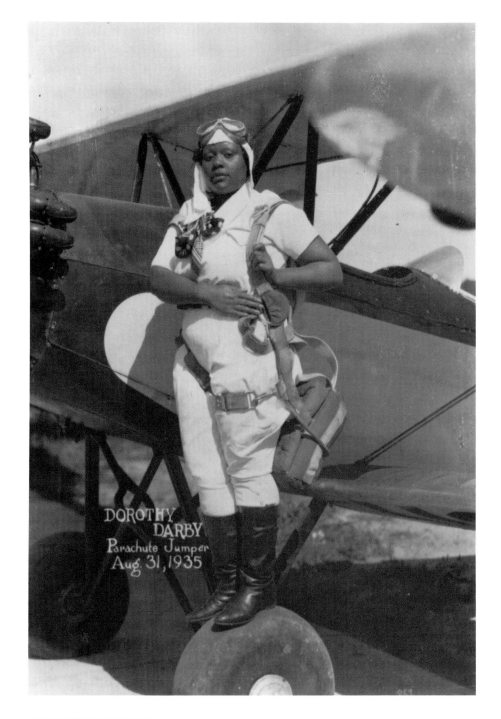

**LEAPING LADY (1935)**

Dorothy Darby made her mark by dropping in on folks.

*(Courtesy Western Reserve Historical Society)*

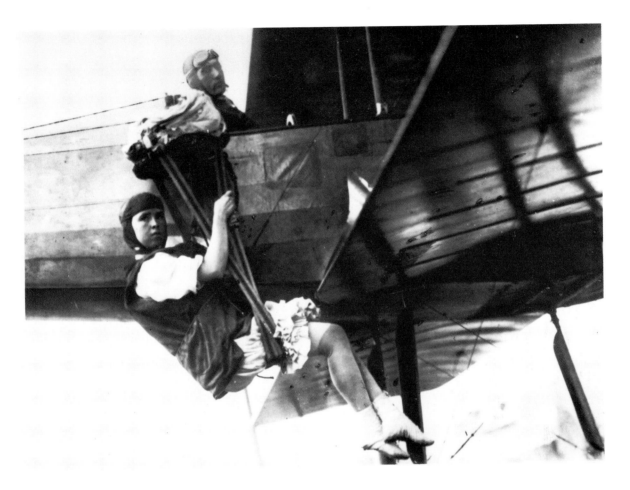

## TINY (1913)

Georgia "Tiny" Thompson Broadwicke of Henderson, North Carolina, became the first woman to parachute from an airplane. Here on the day of her first jump at Griffith Field in Los Angeles she sits on a trap seat under a seaplane piloted by Glenn Martin.

*(Courtesy North Carolina Division of Archives and History)*

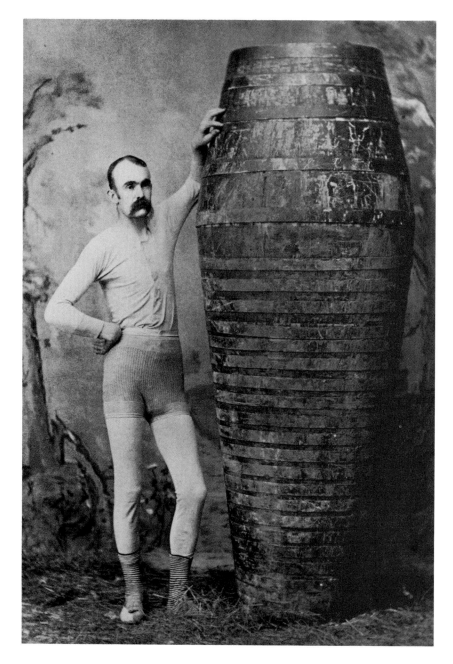

**THE HERO OF THE WHIRLPOOL RAPIDS AND HIS BARREL (1886)**

Carlisle Graham made two successful trips through the treacherous Whirlpool
Rapids at Niagara Falls in the above barrel, which he constructed himself. To add
some spice, he performed the feat the second time with his head out of the barrel.
According to the October 13, 1901, *Niagara Falls Gazette*, Annie Taylor's trip over
the more dangerous Horseshoe Falls put Graham's accomplishment "in the shade,"
forcing him to announce that he and Martha Wagenfurer would go over American
Falls together. Nothing further came of this.

*(George E. Curtis; courtesy Buffalo and Erie County Historical Society)*

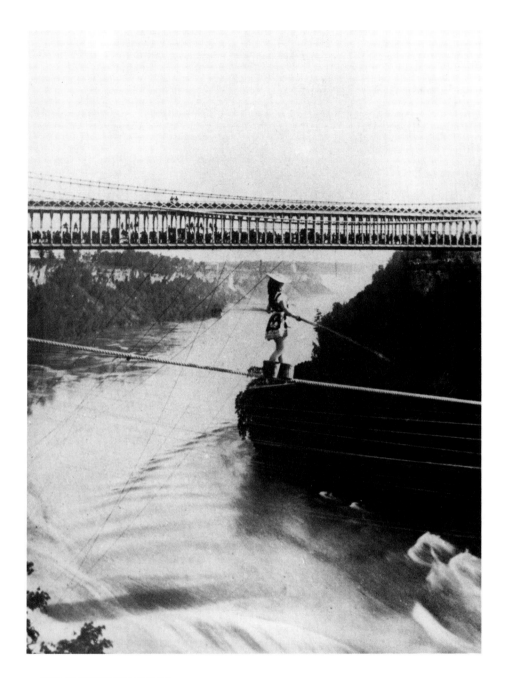

**ONE-UPMANSHIP (1876)**

Maria Spelterina was the first and only woman to cross Niagara Falls on a tightrope.
In order to add a twist to the feat, accomplished before her by Blondin, she wore
bushel baskets on her feet.

*(Courtesy Niagara Falls Museum)*

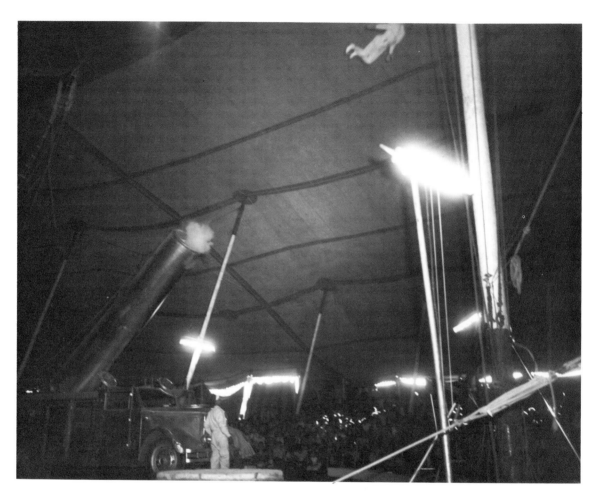

## ZACCHINI—THE HUMAN PROJECTILE (circa 1930)

The Zacchini family was internationally famous, appearing as "projectiles" with Ringling Brothers and Barnum & Bailey Circus from the late 1920s to the late 1930s. Their Human Cannonball act started as a single shot, but the ever-inventive Zacchinis created the "Monster Repeating Cannon," which fired two people out of the barrel in rapid succession. What made the act unique was that the second person out of the barrel traveled faster than the first one and actually passed him at the apex of their trajectory. A brief blast of compressed air gave them their boost and reportedly caused a momentary blackout for both launchees. They would land, one after the other, in a large net 150 feet away. Many serious injuries resulted from this form of entertainment.

*(Courtesy Circus World Museum, Baraboo, Wisconsin)*

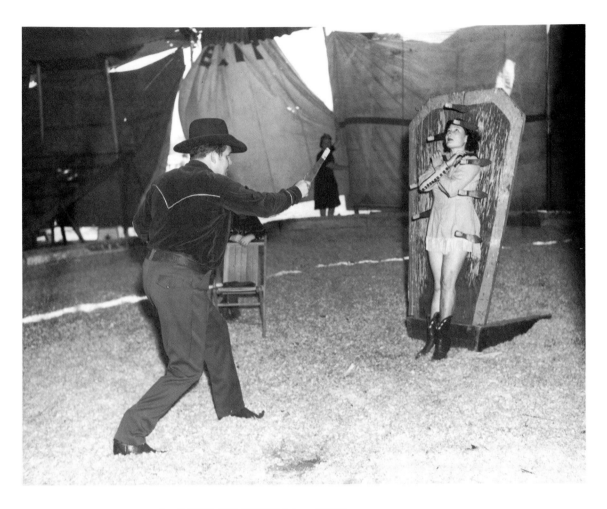

**TEX AND ALICE ORTON ON TARGET (circa 1930)**

Alice Orton was Tex's stepdaughter, and rumor had it that she would quit the act for a few weeks every year—around report-card time.

*(Courtesy Circus World Museum, Baraboo, Wisconsin)*

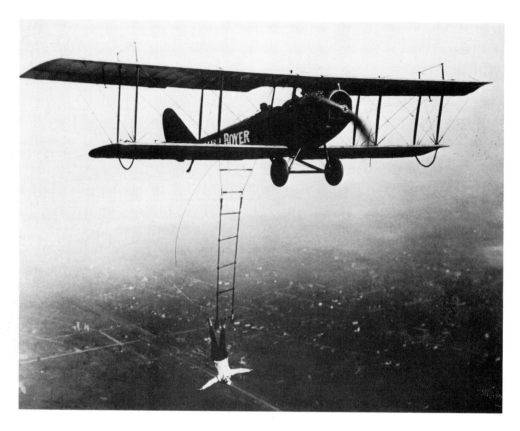

**THRILL DAY**

"Thrill Day" at the Minnesota State Fair began in 1922 with an eighteen-year-old Chicago schoolgirl named Lillian Boyer, who claimed to be "the only aviatrix in the world to make passes from an automobile to an airplane," and through the late 1930s attendance records were broken each successive year. Boyer flew in a Curtiss JN-4, sold by the government and often purchased by daredevils and stunt pilots. Other Thrill Day events included "an airplane crash, a multiple parachute jump event, airplane, motorcycle and automobile races, several daredevil air and track stunts and an appearance of Clem Sohn, 'the human bat.'"

This just goes to show that Minnesotans know how to have a good time.

(Minneapolis Star-Journal; *courtesy Minnesota Historical Society*)

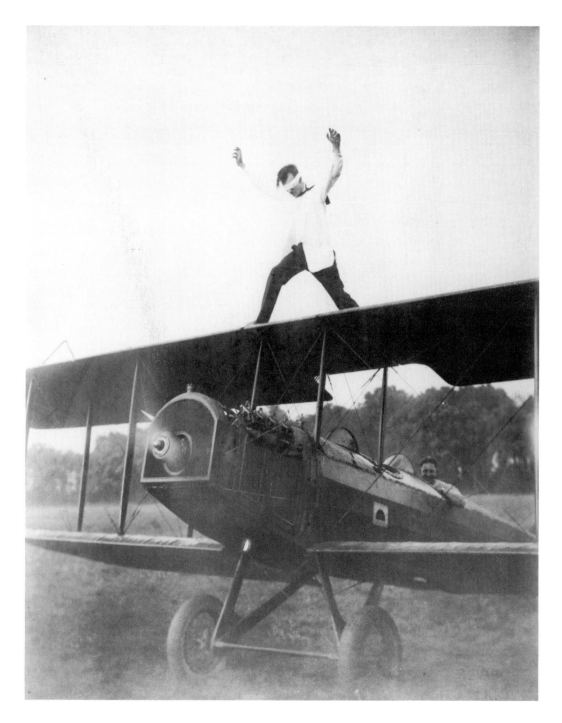

**BLINDFOLDED DAREDEVIL ON AIRPLANE (circa 1925)**

It is not known if this plane ever left the ground with the daredevil atop.

*(George F. Lartz; courtesy Chicago Historical Society, #ICHi-20926)*

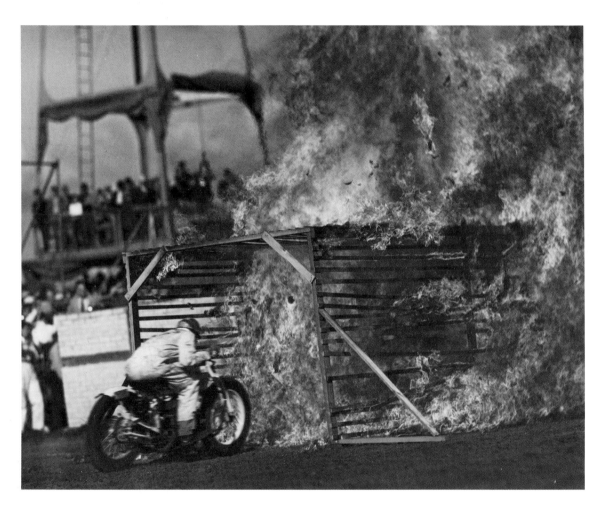

**INTO THE INFERNO (1937)**

Motorcyclist Charles Doyle drove through a flaming barrier, putting himself on crutches and out of commission for nearly two years. His broken leg mended, he went on to perform many more daring stunts.

(Minneapolis Star-Journal; *courtesy Minnesota Historical Society*)

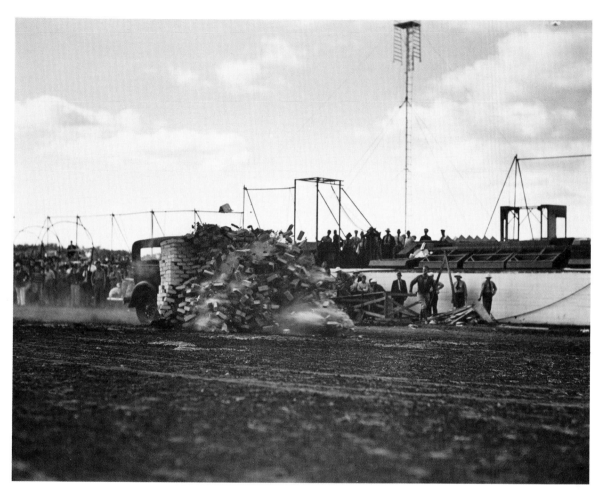

**HEAD ON (1937)**

Marion Swanson crashed through a brick wall in the name of entertainment.

(Minneapolis Star-Journal; *courtesy Minnesota Historical Society*)

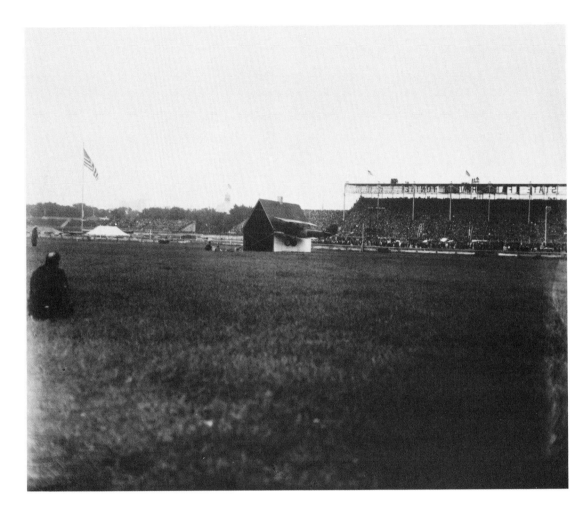

**HOMEWRECKER (1935)**

Movie stunt pilot F. F. Frakes intentionally crashed his plane into a house. Flames broke out and both plane and house were completely destroyed, but Captain Frakes emerged unscathed.

*(Courtesy Minnesota Historical Society)*

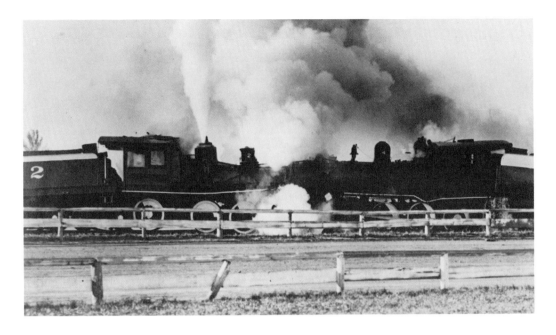

**ALL REVVED UP WITH NO PLACE TO GO (1934)**

In the most thrilling event at Thrill Day, train crews set their throttles, then jumped from speeding locomotives, which were smashed together for paying spectators.

(St. Paul Pioneer Press; *courtesy Minnesota Historical Society*)

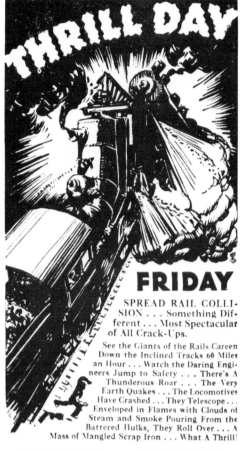

# THRILL DAY

## FRIDAY

**SPREAD RAIL COLLI-SION . . . Something Different . . . Most Spectacular of All Crack-Ups.**

See the Giants of the Rails Careen Down the Inclined Tracks 60 Miles an Hour . . . Watch the Daring Engineers Jump to Safety . . . There's A Thunderous Roar . . . The Very Earth Quakes . . . The Locomotives Have Crashed . . . They Telescope . . . Enveloped in Flames with Clouds of Steam and Smoke Pouring From the Battered Hulks, They Roll Over . . . A Mass of Mangled Scrap Iron . . . What A Thrill!

### WALL CRASH

● See . . . Marion Swanson Pilot Her Racing Auto Through a Plank Wall . . . The Hair-Raising Balloon and Airplane Parachute Jumps . . . The Bike Races . . . The Motorcycle Rodeo of the State Highway Patrol . . Friday Afternoon, Sept. 7. THRILL DAY ONLY.

### NIGHT SHOW

● See Diamond Jubilee, Night Show Extraordinary . . . A Glittering, Glamorous Spectacle Combining Mirth, Drama, Beautiful Rhythmic Dancers with New and Startling Sound and Lighting Effects . . . All Climaxed with Special Jubilee Fireworks . . . Grandstand Each Evening.

### WRESTLING

● See the Five Star Wrestling Card . . . Jim McMillen, Great Illini Grid Star vs. Abe Kashey, the Old Meanie . . . Cliff Olson, Former Gustavus Adolphus Athlete vs. Roughhouse Joe Cox . . . Milo Steinborn, Vin Lopez and Others. Saturday Eve., September 8, Hippodrome.

### TRAP SHOOT

● See the World's Greatest Trapshooters . . . Hundreds, Yes, Thousands of Pigeons, Clay, of Course, Will be Shattered by 300 Gunners Competing in the First Annual Northwestern Class Championship Trapshooting Tournament . . . Two Days, September 7 and 8.

# MINNESOTA STATE FAIR
**Admission 25¢**
# SEPT. 1 to 8

*(Courtesy* Minneapolis Journal, *September 6, 1934)*

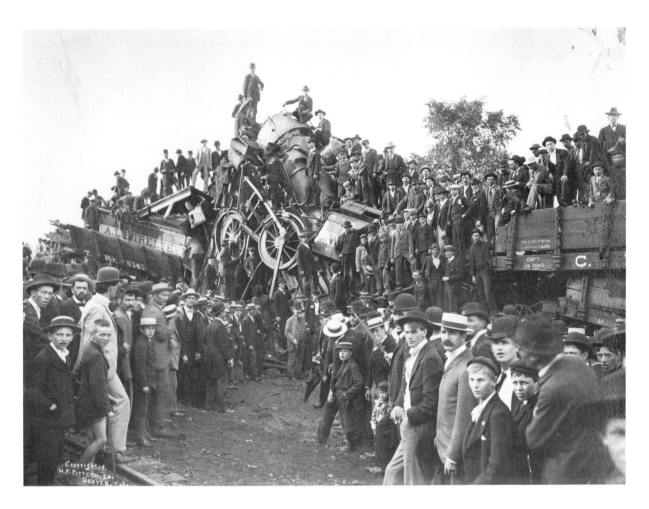

**SOUVENIR HUNTING (1896)**
*(H. F. Pierson, Denver, Colorado; courtesy Library of Congress)*

*On many occasions old steam locomotives would be smashed together for paying
spectators, the crews setting the throttles and then jumping off. This 1896 "crash"
crowd was photographed by H. F. Pierson of Denver. Another big head-on bang in
1896, put on by a man aptly named W. G. Crush before thirty thousand Texans in
Waco, got out of hand. Flying scraps of boiler killed one spectator and badly hurt
two photographers.* —Oliver Jensen, from *America's Yesterdays*

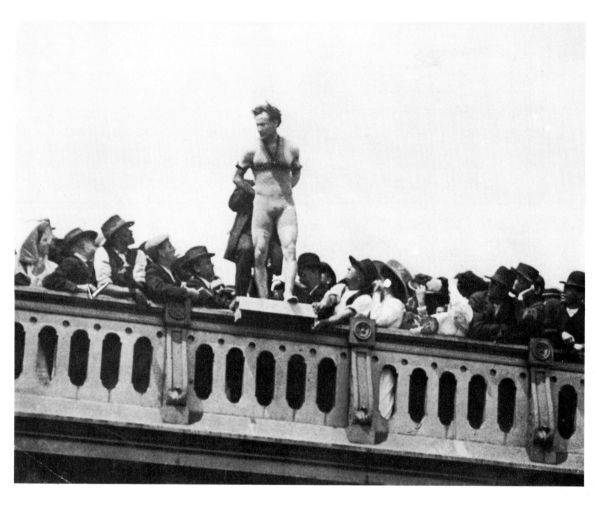

**HOUDINI (1908)**

Houdini prepared to jump into the Charles River from Harvard Bridge, Boston, Massachusetts.

*(Courtesy Houdini Magical Hall of Fame)*

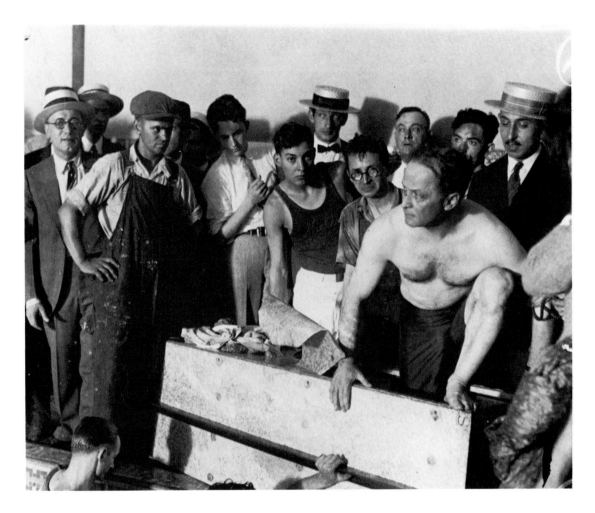

**HOUDINI (1925)**

Houdini stepped out of an airtight box after remaining submerged for an hour and a half in the pool of the Hotel Shelton, in New York City. Always anxious to expose quackery, here Houdini disproved the claim that only "yogis" with special mystical training could survive being "buried alive."

*(Courtesy Houdini Magical Hall of Fame)*

*A hero ventures forth from the world of the common day into a region of supernatural wonder: fabulous forces are there encountered and a decisive victory is won; the hero comes back from this mysterious adventure with the power to bestow boons on his fellow man.* —Joseph Campbell, *The Hero with a Thousand Faces*

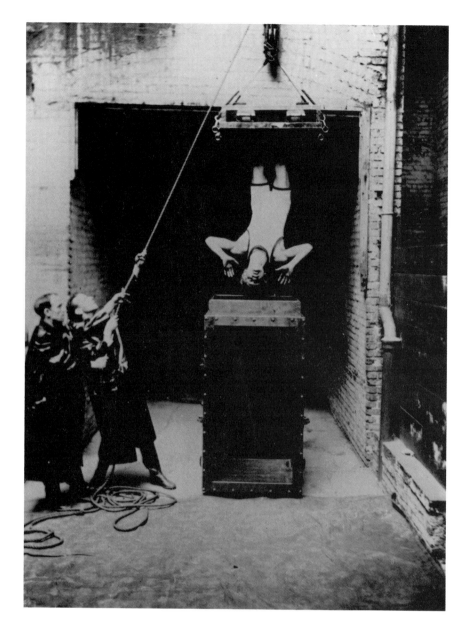

**HOUDINI (1913)**

Men in raincoats lowered Houdini into the "Water Torture Cell." Contrary to the Hollywood film version of his life (starring Tony Curtis), Houdini did not die in the Water Torture Cell. Death resulted from a young man's challenge to his claim that he could withstand anyone's punch to his abdomen. The young man delivered his blow before Houdini was ready, rupturing his appendix. Houdini performed the following night and died several days later, on October 31, 1926—Halloween. To this day, séances are held on the anniversary of his death in hopes of contacting the man who could escape from everything else.

*(Courtesy Houdini Magical Hall of Fame)*

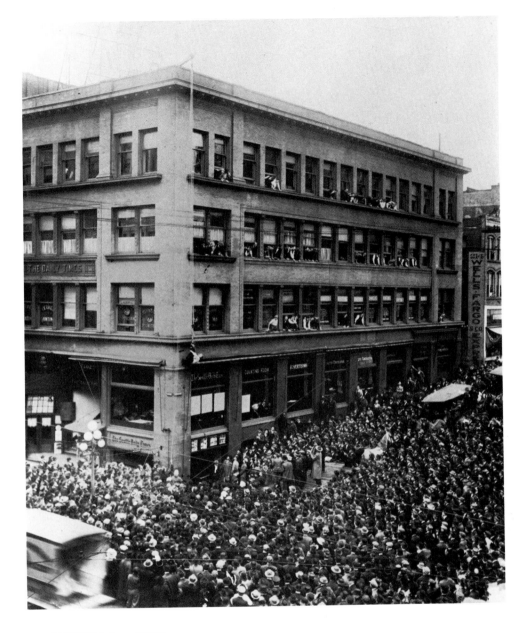

**HOUDINI (circa 1923)**

The master of derring-do, Houdini dangled daringly upside-down in a straitjacket, above a crowd gathered in front of the Seattle Daily Times Building.

*(Pringle and Booth; courtesy Houdini Magical Hall of Fame)*

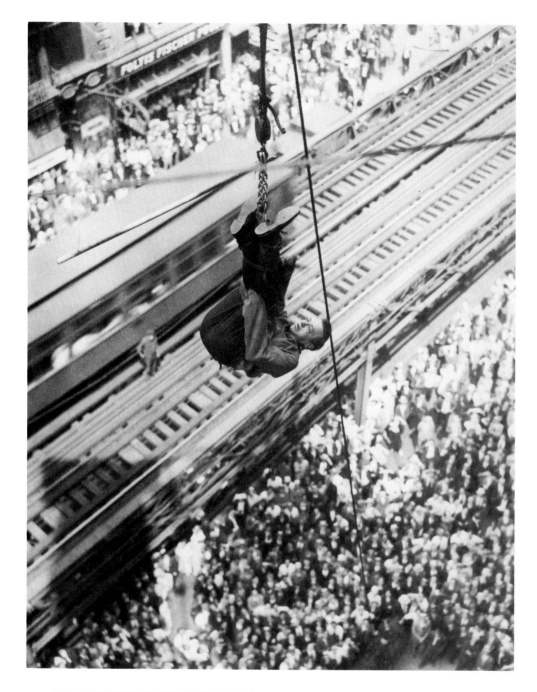

**THE GREAT HUBER OUT-HOUDINIS HARRY (1931)**

This photograph shows "The Great Huber," who claimed the world's record for the fastest escape from a straitjacket. Closely confined and suspended by his feet from the Hippodrome cupola, he made a clean and clever getaway. Huber was an internationally known magician, and this picture documents a record escape that was one minute and one second faster than the late illustrious Harry Houdini's.

(The New York Times; *courtesy National Archives and Wide World Photos*)

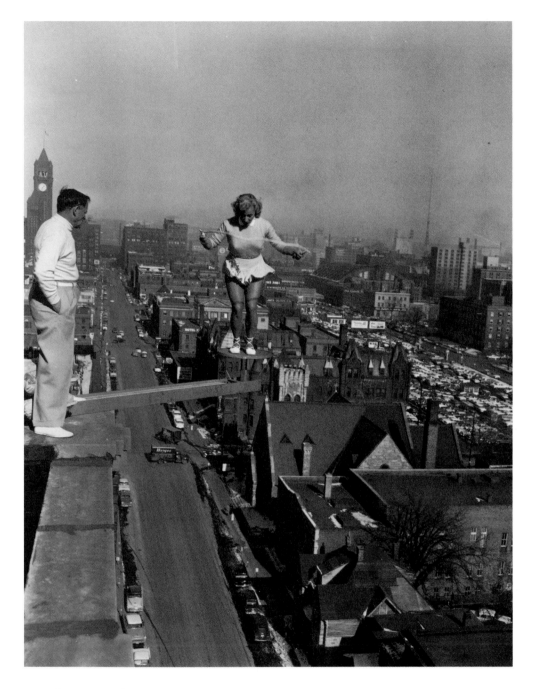

**SKIPPING ROPE (1956)**

Shrine Circus aerialist Betty Fox skipped rope and performed acrobatic feats on an 18-inch stool cantilevered from the rooftop of the Curtis Hotel, twenty-one stories above 4th Avenue in Minneapolis, Minnesota. Her husband, Benny, assisted.

*(Minneapolis Star Tribune; courtesy Minnesota Historical Society)*

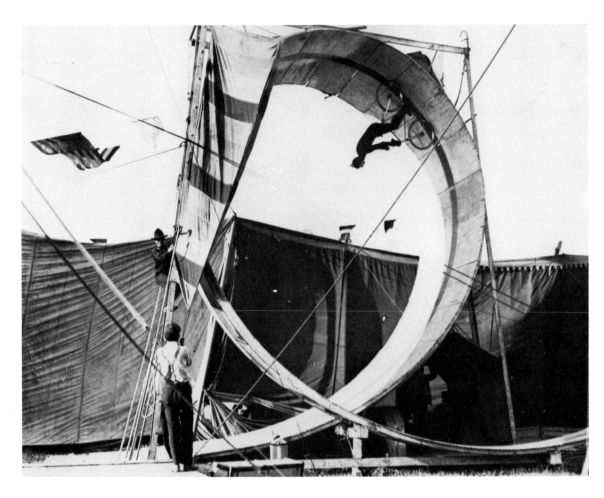

**THE DIAVOLO'S FATAL RIDE (circa 1915)**

Daredevil Diavolo, the first man to loop-the-loop on a bicycle, died later the same
year doing this stunt.

*(Courtesy Chicago Historical Society, #ICHi-20819)*

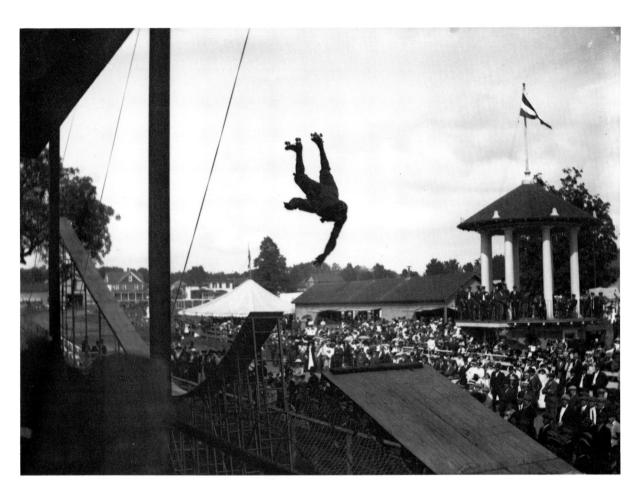

**HIGHER GROUND (1910)**

A daredevil on roller skates set his sights high at the Otsego,
New York, County Fair.

*(A. J. Telfer; courtesy New York State Historical Association)*

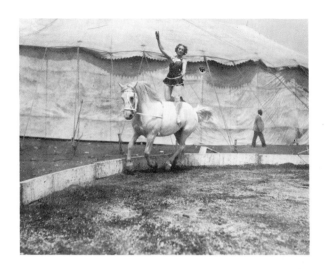

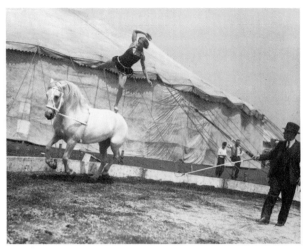

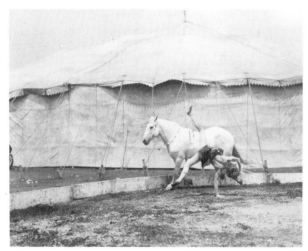

**EQUESTRIAN MISHAP (circa 1930)**

These three photographs provide a rare behind-the-scenes look at a rehearsal by Rose Wallet, an equestrian performer. Even people who seem larger than life under the big top have their ups and downs.

*(Courtesy Circus World Museum, Baraboo, Wisconsin)*

# NATURAL HISTORY

The road to excess leads to the palace of wisdom . . .

for we never know what is enough

until we know what is more than enough.

**William Blake**

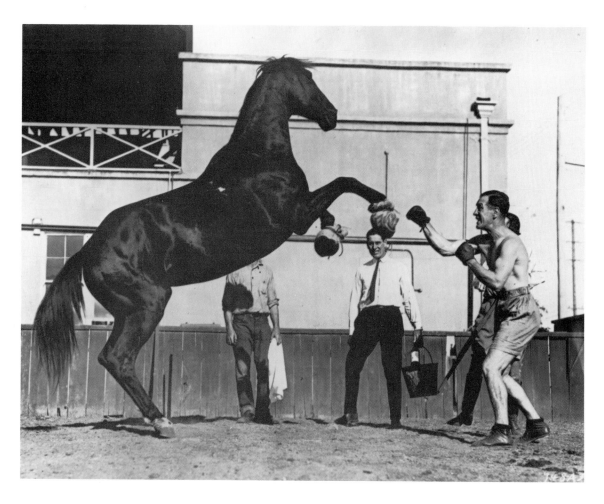

**MUSTANG MEETS HIS MATCH (circa 1926)**

This horse was billed as a contender for the heavyweight boxing championship of
the equine world. Not satisfied with the ordinary sparring partners, Raymond
Johnstone, a pugilist, put on the gloves with "Mustang" for a few rounds in Los
Angeles. Johnstone found that he had to dodge not only flying hoofs but also his
opponent's teeth, so that his agility was given a thorough test.

*(Underwood and Underwood; courtesy Underwood Photo Archives, San Francisco)*

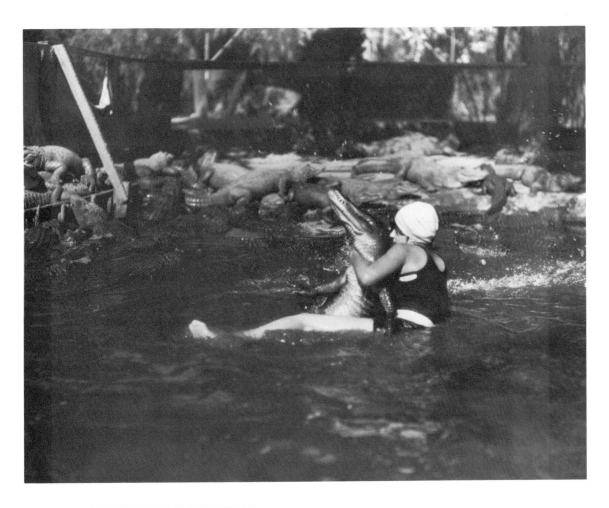

**A HAZARDOUS PASTIME (1927)**

Sixteen-year-old Eleanor Link had an unusual hobby: wrestling with lively alligators.
She had studied their habits and treated them quite familiarly but there was always
the chance that one of the saurians might mistake her for an enemy—and create a
"missing link."

*(Underwood and Underwood; courtesy Underwood Photo Archives, San Francisco)*

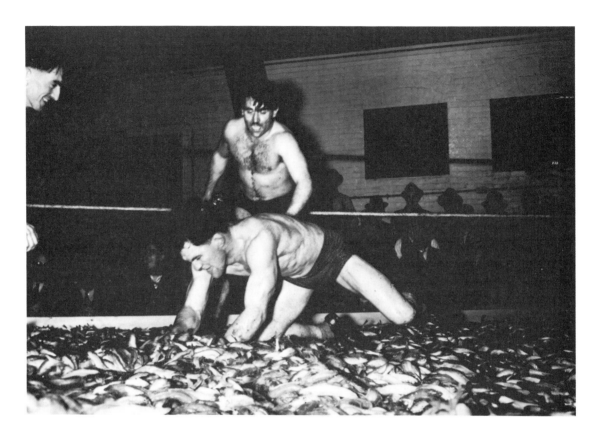

## SMELT WRESTLING (1939)

Originally conceived as a cure for cabin fever, smelt wrestling quickly swept the smelt belt as the antidote for those eternal Wisconsin winters. Here at the 1939 Marinette Smelt Carnival, grapplers competed in a ring covered with the tiny fish. It is not known whether the fish were dead or alive at the time of the match.

*(Courtesy State Historical Society of Wisconsin)*

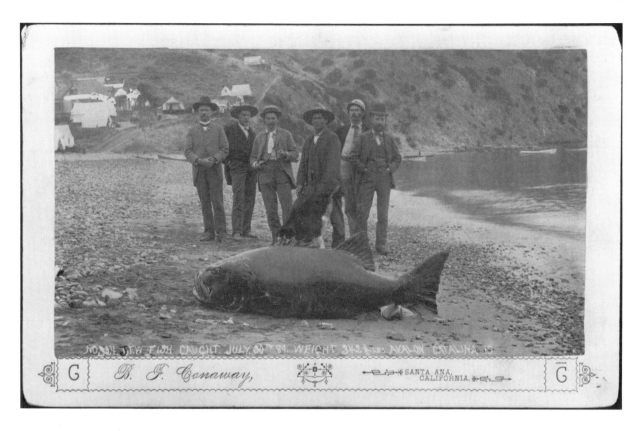

**PRIZE CATCH (1884)**

A jewfish caught on July 20, 1884, at Avalon, California, on Catalina Island,
weighed 342 pounds.

*(B. F. Canaway; courtesy California State Library)*

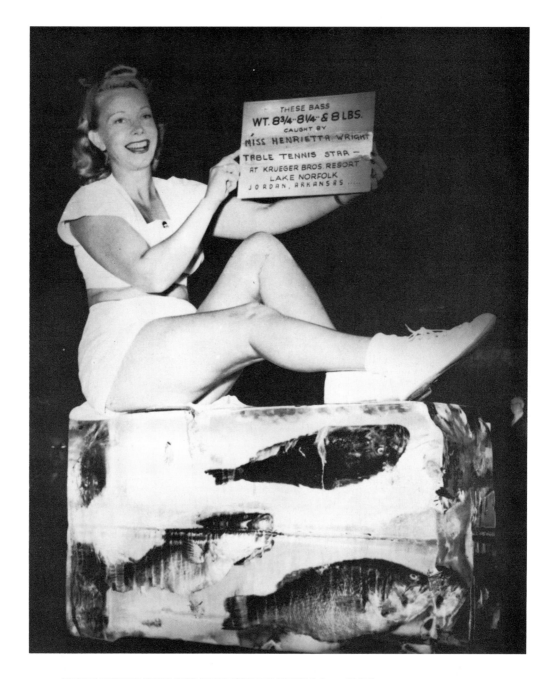

**TABLE TENNIS STAR AND BLUE RIBBON BASS (circa 1945)**

At the Krueger Brothers Resort in Jordan, Arkansas, table tennis champion and all-around athlete Miss Henrietta Wright sits atop her prizewinning bass catch. The fish were caught in nearby Lake Norfolk.

*(Courtesy State Historical Society of Wisconsin)*

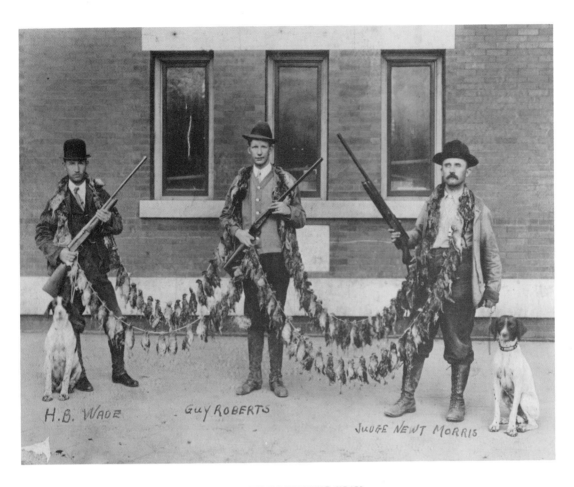

H.B. WADE     GUY ROBERTS     JUDGE NEWT MORRIS

**JUDGE NEWT MORRIS AND FRIENDS GO BIRDING (1910)**

After a two-day outing, Judge Newt Morris and his friends had bagged 192 birds and posed with their dogs in front of the courthouse in Marietta, Georgia.

*(Courtesy Vanishing Georgia Collection, Georgia Department of Archives and History)*

**ANIMAL IMPERSONATORS WITH TRAINER (circa 1930)**

The circus is full of unusual acts. H. A. Atwell's photographic credits read like a
Who's Who of the circus biz. All of the greats came to his Chicago studio at one
time or another.

*(H. A. Atwell; courtesy Circus World Museum, Baraboo, Wisconsin)*

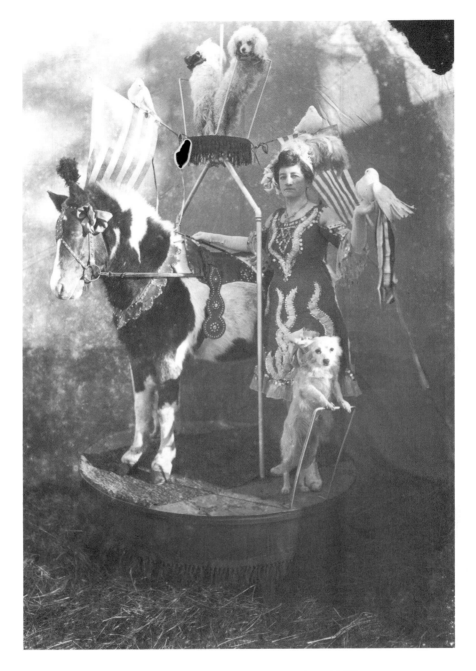

**MAUDE HOCUM WITH HER DOG-AND-PONY SHOW (circa 1920)**

Maude Hocum came from a family of famous equestrians who toured with major circuses. In back-lot parlance, there were two types of shows—low grass and high grass. Low-grass shows were held in cities or large towns on mowed lots, while high-grass shows took place in rural areas in farmers' fields. The occasional dog-and-pony show would travel on its own, apart from any circus, but these acts were strictly high grass.

*(Courtesy Circus World Museum, Baraboo, Wisconsin)*

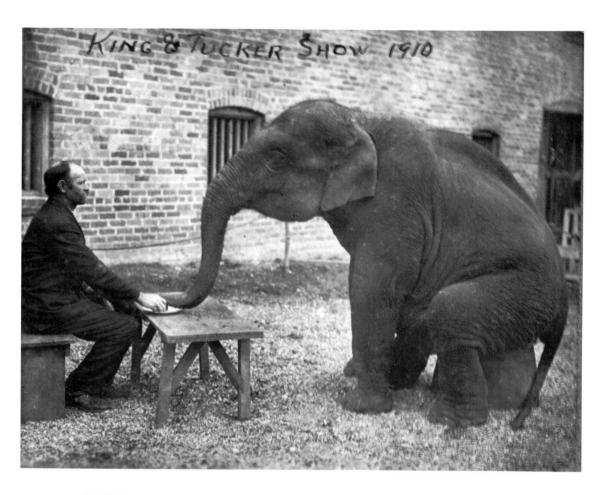

**BACK-LOT LUNCH (1910)**

This elephant and his trainer, both members of the King and Tucker show, were
photographed in a relaxed moment having their lunch.

*(Author's collection)*

**CHEERFUL GARDNER—THE HUMAN PENDULUM (circa 1930)**

Cheerful Gardner was a legendary elephant trainer with the Hagenbeck Wallace
Circus who obviously had a way with elephants. He trained elephants at the circus
to do all their various tricks (including magic), but none was as crowd-pleasing
as this one.

*(Century Studios; courtesy Circus World Museum, Baraboo, Wisconsin)*

**KASSINO MIDGETS AND DOG (circa 1910)**

Midgets and clowns were always part and parcel of the circus, but, if truth be
known, they were often used as filler during rigging changes. Some, however,
became very popular with the crowds. The Kassino Midgets stole the show.

*(Courtesy Circus World Museum, Baraboo, Wisconsin)*

## GIANT HAILSTONES (1897)

The storm hit Topeka, Kansas, at 6:30 P.M. on June 24 with a force that made
many residents think it was a tornado. Huge hailstones fell for about five minutes,
and when the storm had passed, Topekans rushed out to see them. Because it was
summer, measurements and photographs had to be taken quickly. The largest
hailstone left by the Topeka storm was documented to weigh 14½ ounces and
measure 14 inches in circumference. The giant ice balls wrought great damage
to trees, houses, and businesses, the greatest to skylights and storefront windows
exposed to the west. The estimated cost of damage at the time was fifty
thousand dollars.

*(W. F. Farrow,* Topeka Mail and Breeze; *courtesy Kansas State Historical Society)*

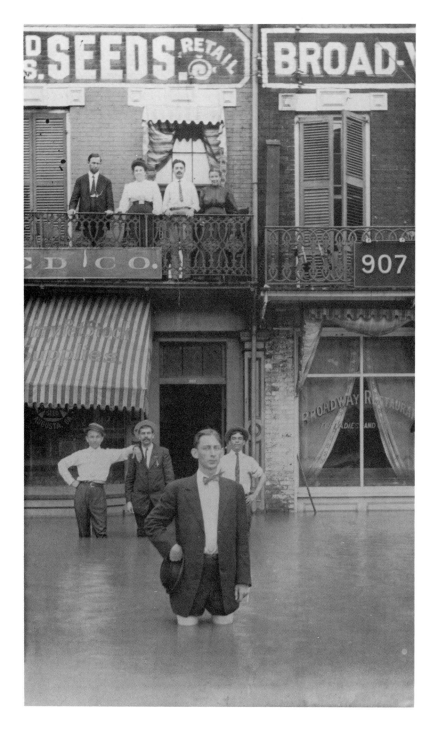

**BROADWAY (1908)**

These dapper civilians paused to have their picture taken after a torrential downpour left Augusta, Georgia, knee-deep in water.

*(Courtesy Vanishing Georgia Collection, Georgia Department of Archives and History)*

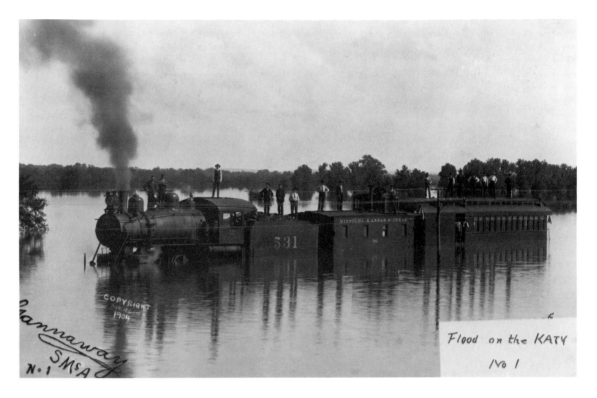

**FLOOD ON THE KATY, NO. 1 (1904)**

This is the kind of thing that keeps armchair travelers in their seats.

*(Gannaway; courtesy Library of Congress)*

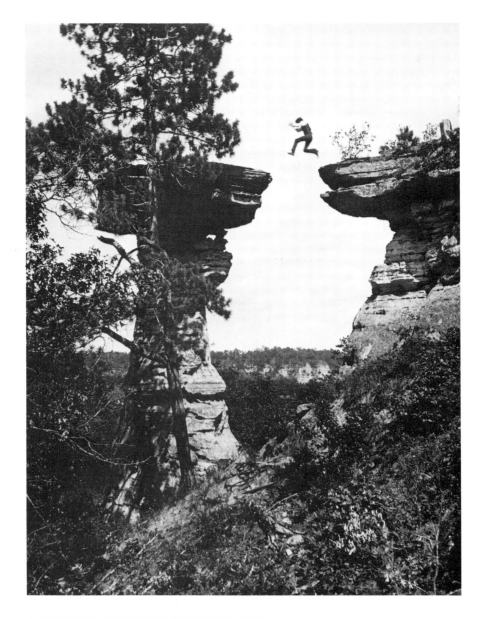

**LEAPING THE CHASM AT STAND ROCK (1886)**

Many photographic historians consider this the first "instantaneous," or stop-action, photograph. Printed from the original glass-plate negative, it was taken at the Wisconsin Dells by H. H. Bennett, a photography pioneer. While Bennett's colleagues had to physically remove and replace the lens cap for the appropriate number of seconds (or minutes) to make an exposure, he had patented a rubber-band shutter that enabled him to "freeze" a moving subject. Bennett's original studio, still intact and operated by his granddaughter, is the oldest continually operating commercial photography studio in the United States.

*(H. H. Bennett; courtesy H. H. Bennett Studio Foundation)*

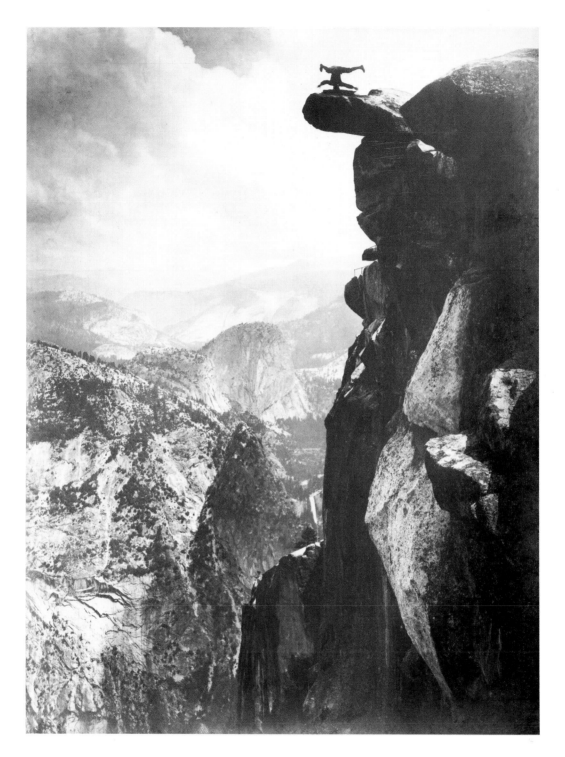

**BALANCED ON HIS HEAD (circa 1906)**

Yosemite, California

*(Courtesy Library of Congress)*

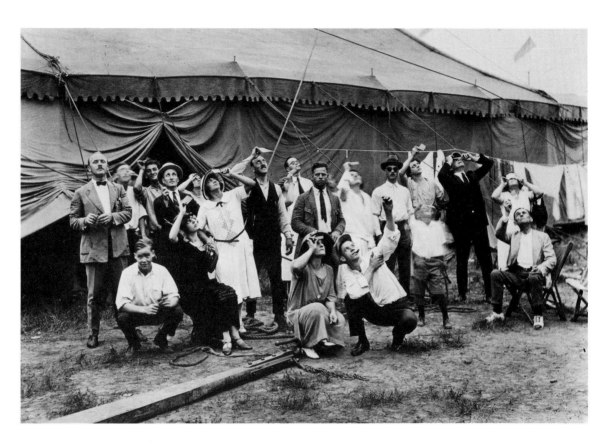

**CIRCUS PERFORMERS OBSERVING AN ECLIPSE OF THE SUN (circa 1925)**

Performers from Ringling Brothers and Barnum & Bailey Circus slipped out from under the big top with pinhole viewers to observe something even more spectacular than themselves: a solar eclipse.

*(Courtesy State Historical Society of Wisconsin)*

# SAFETY IN NUMBERS

Dangerously we must live!

Nietzsche

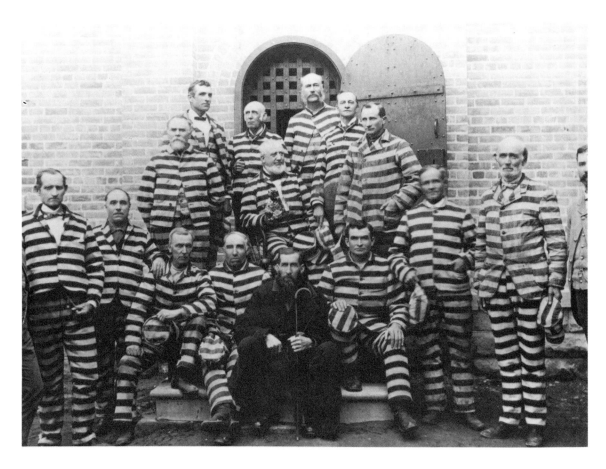

**POLYGAMIST PRISONERS (1895)**

Pictured here—without their wives—are prisoners of the Sugar House section of the Utah State Penitentiary: George Q. Cannon, center, holding flowers; to his left is Joseph Stacy Murdock from Heber, Utah; Alonzo Kimball is on the lower step in black. Others include David M. Stuart and Andrew Wood Cooley, bishop of Brigham Ward. Their only crime was too many wives.

*(Courtesy Utah State Historical Society)*

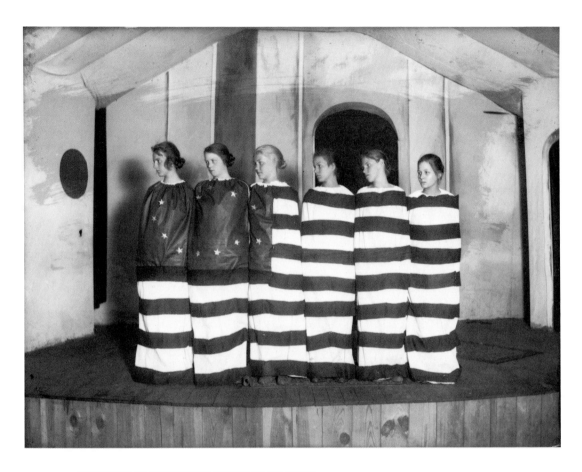

**PAGEANT AT THE GIRLS' ORPHANAGE (1918)**

Betsy Ross may not have stitched their dresses, but these girls from the
Cooperstown, New York, orphanage formed a fine flag for their annual pageant.

*(A. J. Telfer; courtesy New York State Historical Association)*

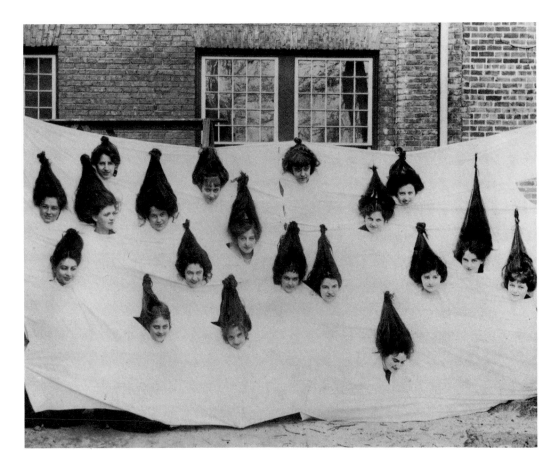

**A HAIR-RAISING SCHEME (1912)**

Secret organizations became fashionable at Brenau College in Gainesville, Georgia, around 1900. Members of the secret G.S.G. Club at Brenau posed for a photograph that appeared in the college yearbook, *Bubbles*. This club was listed in the yearbook for only one year. The society was so secret that Brenau College has no information about it today.

*(Courtesy Vanishing Georgia Collection, Georgia Department of Archives and History)*

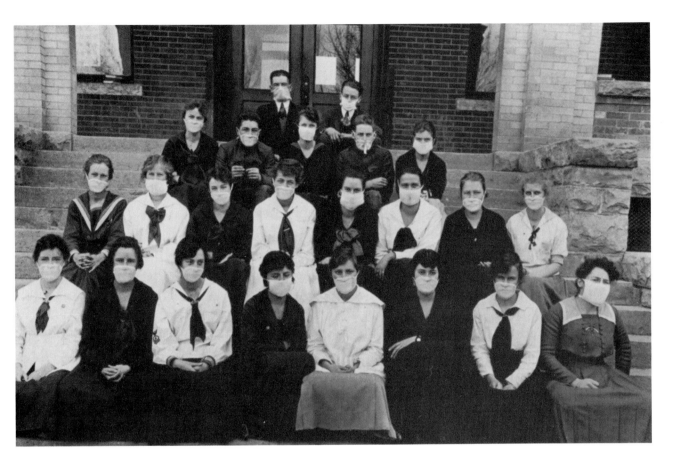

**SAFETY FIRST (1919)**

Determined to have their class picture taken during an influenza epidemic, these brave students at Canon City (Colorado) High School donned masks for their class portrait.

*(Courtesy Canon City High School and Colorado Historical Society)*

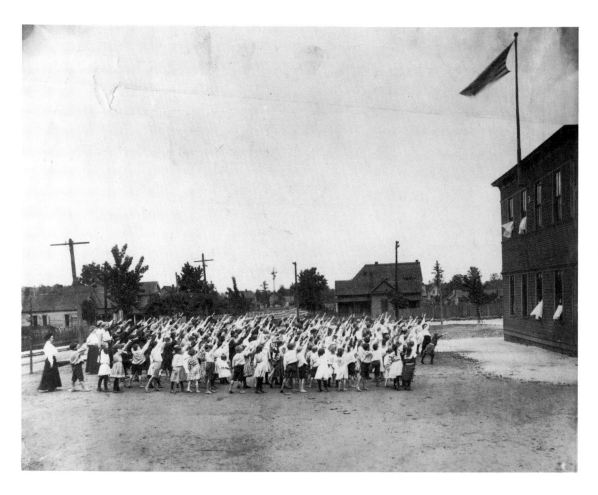

**SAYING THE PLEDGE (circa 1912)**

These elementary-school children saluted the U.S. flag with the old straight-arm
salute. The current hand-over-the-heart pledge of allegiance was adopted after
World War II.

*(Courtesy Alabama Department of Archives and History)*

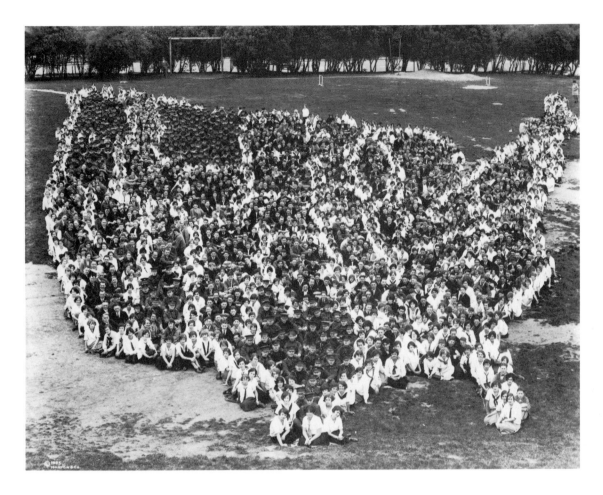

**HUMAN MAP OF THE U.S.A. (1925)**

Over a thousand men and women formed this patriotic portrait of the then forty-eight states on a school playing field in San Francisco, California.

*(Morton & Co.; courtesy Library of Congress)*

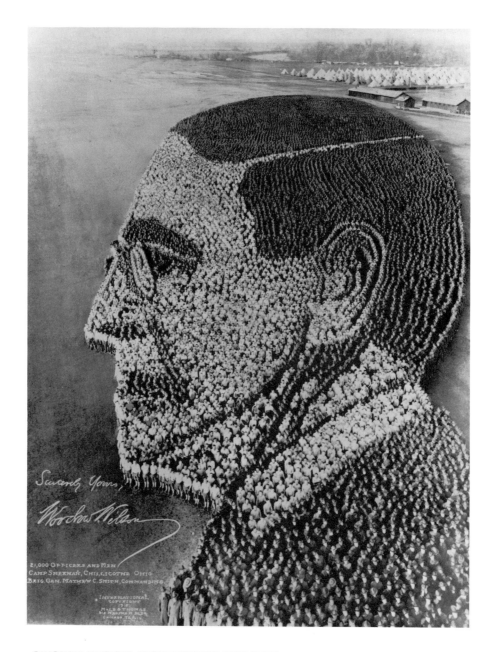

**SINCERELY YOURS, WOODROW WILSON (1919)**

"Living insignias" were all the rage with military units during the 1920s and 1930s. Itinerant photographers made a good living visiting military bases and selling these portraits to the soldiers for one dollar each. Soldiers often sent these souvenirs home to proud parents, wives, and girlfriends. At Camp Sherman in Chillicothe, Ohio, 21,000 officers and men, with Brigadier General Matthew C. Smith commanding, formed a giant, living portrait of their president, and parted his hair with military precision.

*(Mole & Thomas; courtesy Western Reserve Historical Society)*

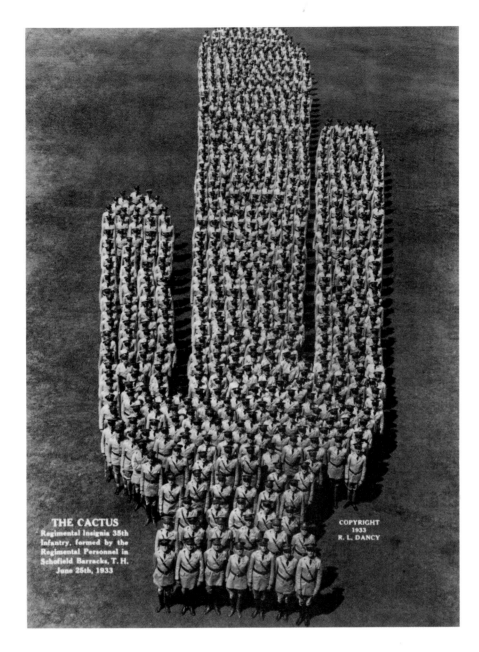

The cactus. Regimental insignia 35th Infantry, formed by the Regimental Personnel in Schofield Barracks, T. H. June 25th, 1933. Copyright 1933 R. L. Dancy

## REGIMENTAL CACTUS (1933)

In 1933 the officers of the 35th Infantry at Schofield Barracks, Territory of Hawaii, stood in formation to create their regimental insignia: a cactus.

*(R. L. Dancy; courtesy Library of Congress)*

**ELKS (1908)**

In this group portrait, the Racine, Wisconsin, chapter of the Benevolent and
Protective Order of the Elks shows off its ceremonial headgear.

*(Courtesy State Historical Society of Wisconsin)*

# FEATS OF STRENGTH

Everyone should consider his body as a priceless gift . . .

a marvelous work of art, of indescribable beauty, and mastery

beyond human conception, and so delicate that a word,

a breath, a look, nay, a thought may injure it.

**Nikola Tesla**

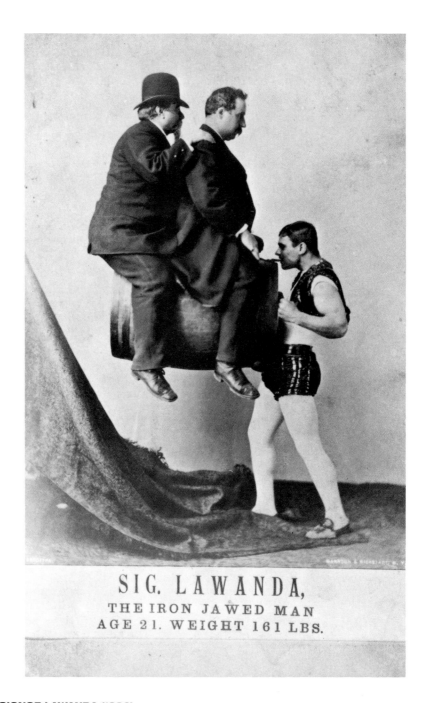

SIG. LAWANDA,
THE IRON JAWED MAN
AGE 21. WEIGHT 161 LBS.

### SIGNOR LAWANDA (1886)

Known as "The Iron-Jawed Man," Signor Lawanda is seen here lifting two men on a barrel at age 21. At the time he weighed only 161 pounds. A few years later, and a few pounds heavier, he improved on his feat by lifting as many as four men at a time, a performance that earned him a place in the 1896 book *Anomalies and Curiosities of Medicine.*

*(Harroun and Bierstadt; courtesy Colorado Historical Society)*

**WHO'S ON FIRST? (1927)**

Supporting a troupe of actresses was a mere incident in the life of strongman
Edward Reese.

*(Underwood and Underwood; courtesy Underwood Photo Archives, San Francisco)*

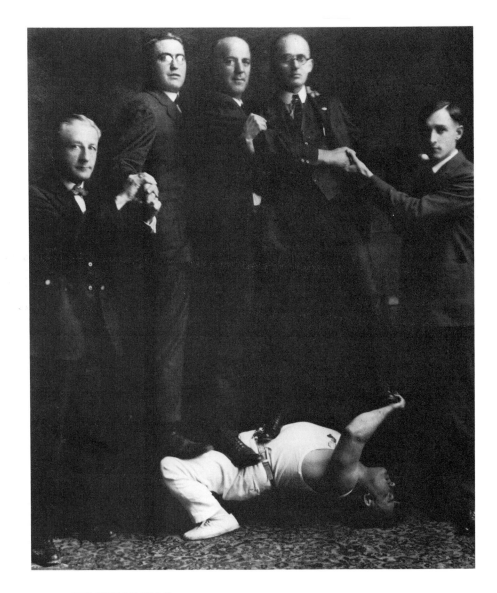

**BANKERS' BRIDGE (1924)**

Max Brenton of Omaha, Nebraska, performed a bridge with three Iowa bankers (together weighing 615 pounds) standing on his chest. Shown in photo from left to right: F. W. Lindeman, cashier, First National Bank, Pocahontas, Iowa; John Loots (weight 225 pounds), cashier, Farmer's Savings Bank, Havelock, Iowa; George Schneiders (weight 215 pounds), cashier, Farmer's Trust and Savings Bank, Pocahontas, Iowa; C. C. Johnson (weight 175 pounds), cashier, Farmer's Trust and Savings Bank, Pocahontas, Iowa; Alfred Miller, assistant cashier, Farmer's Trust and Savings Bank, Pocahontas, Iowa.

Brenton raised the bankers five times in five seconds. He himself weighed 140 pounds, and had previously performed the feat with three men whose combined weight was 820 pounds.

*(Courtesy RIPLEY'S BELIEVE IT OR NOT!®)*

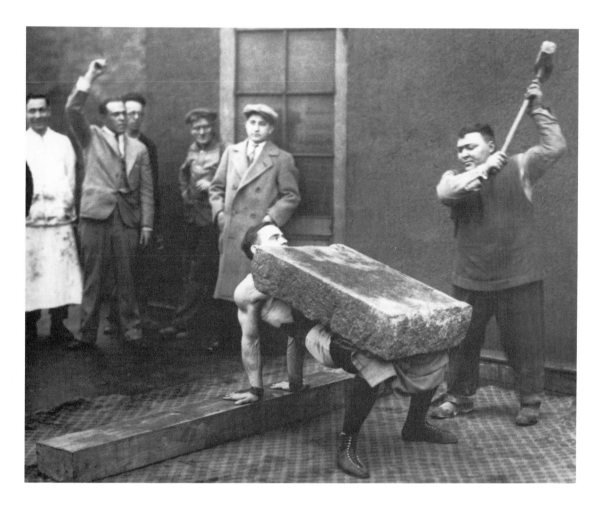

**GREEK STRONGMAN OUT FOR BERLENBACH'S CROWN (1926)**

Gust Lessis, a Greek strongman, was after the lightweight pugilistic crown, which at that time adorned the brow of Paul Berlenbach, "The Astoria Assassin." To prove his prowess, Lessis gave a demonstration of strength just before the match by holding an 800-pound stone slab on his chest while a man with a sledgehammer smashed it to bits.

*(Underwood and Underwood; courtesy Underwood Photo Archives, San Francisco)*

*Be regular and orderly in your life, so that you may be violent and original in your work.* —Flaubert

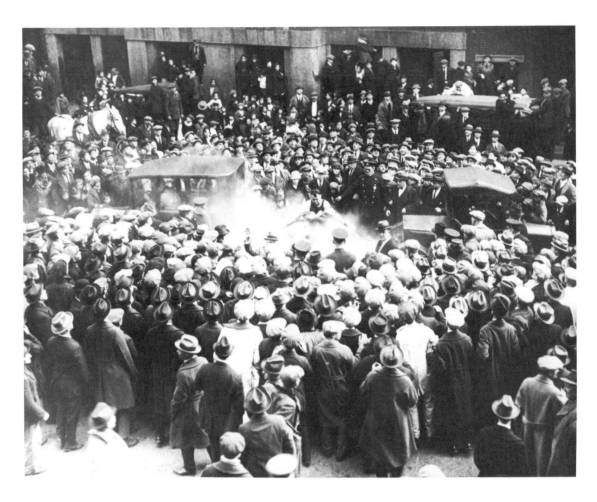

**MAN AGAINST MACHINE (circa 1925)**

Angelo Taramaschi, a legendary strongman, thrilled onlookers in this contest
between muscle and steel.

*(Courtesy Circus World Museum, Baraboo, Wisconsin)*

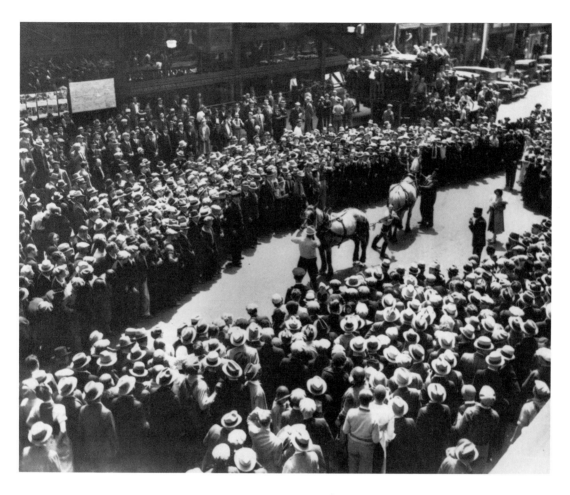

**ONE FOR A MAN, TWO FOR A HORSE (1932)**

Little Sampson, "The World's Strongest Small Man," won this spectacular tug-of-war in front of the Denver Post Building.

(The Denver Post; *courtesy Colorado Historical Society*)

# S T U N T S

**Actions are our epochs.**

Byron, 1817

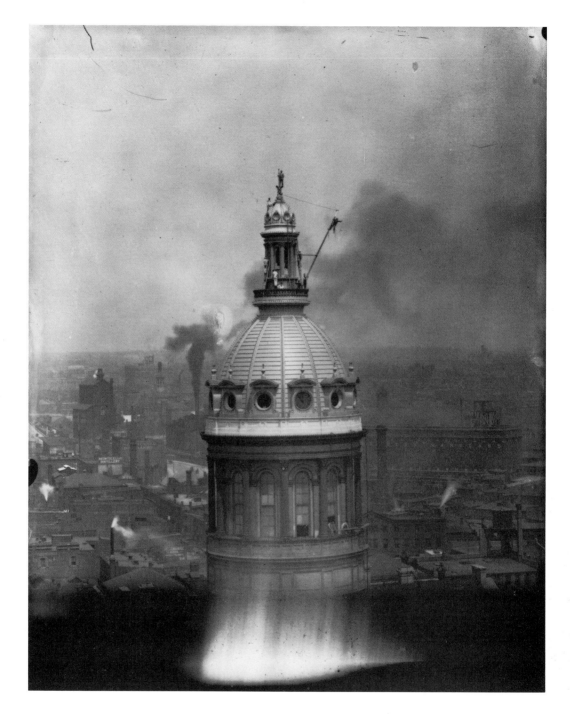

### ONE-ARMED STEEPLEJACK (circa 1924)

One-armed steeplejack Henry Wernsing performed hijinks while painting the dome
of City Hall in Baltimore, Maryland. When not engaged in repairing weather vanes,
flagpoles, and skyscraper clocks, Wernsing amused himself performing as a high-
wire aerialist, parachutist, and hot-air balloonist until his death of a heart attack in
1929. Wernsing's motto was: "Where others fear to tread, I go with pleasure."
*(Courtesy Maryland Historical Society, Baltimore)*

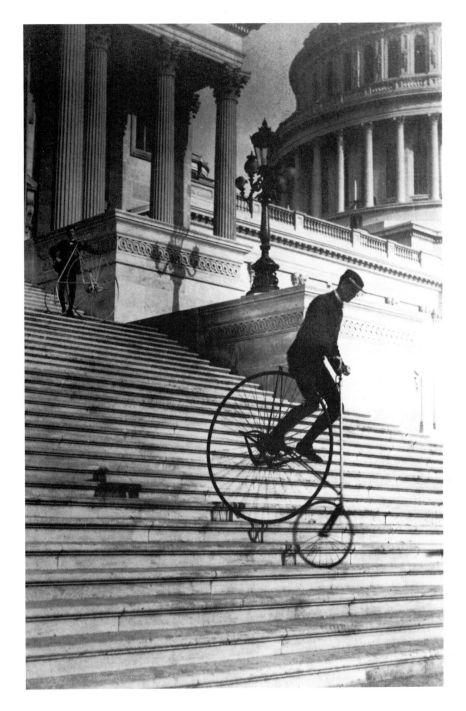

**CAPITOL IDEA (circa 1910)**

This perilous ride on a halfpenny bicycle took place on the steps of the Capitol in Washington, D.C.

*(Courtesy Library of Congress)*

**FLAGPOLE SITTER (1933)**

Flagpole sitting was, for some reason, a popular diversion in Depression-era America. Here one practitioner, Richard Blandy, is seen with his ground crew hoisting up his lunch.

*(Courtesy Chicago Historical Society, #ICHi-20925)*

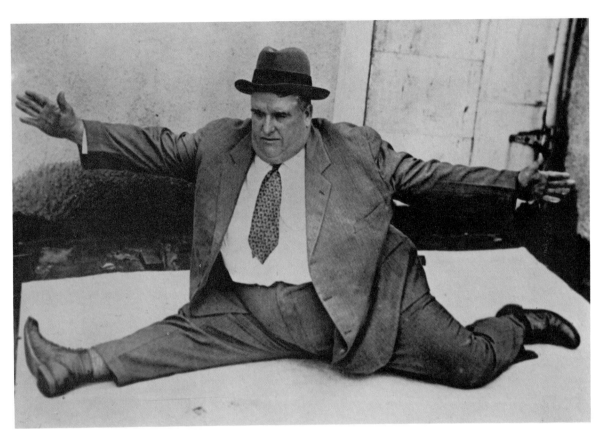

**SPLIT PERSONALITY (circa 1935)**

Choreographers and cheerleaders alike are indebted to this Wall Street financier for giving form to what we now call "the split."

(The New York Times; *courtesy National Archives and Wide World Photos*)

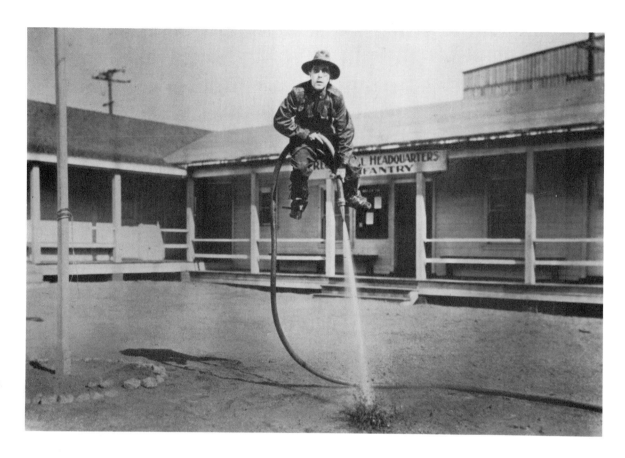

**HIGH-PRESSURE HIJINKS (circa 1923)**

Perhaps this soldier needed a lift. Experimenting with water pressure outside his barracks, he discovered an ingenious alternative to mounted patrol.

(The New York Times; *courtesy National Archives and Wide World Photos*)

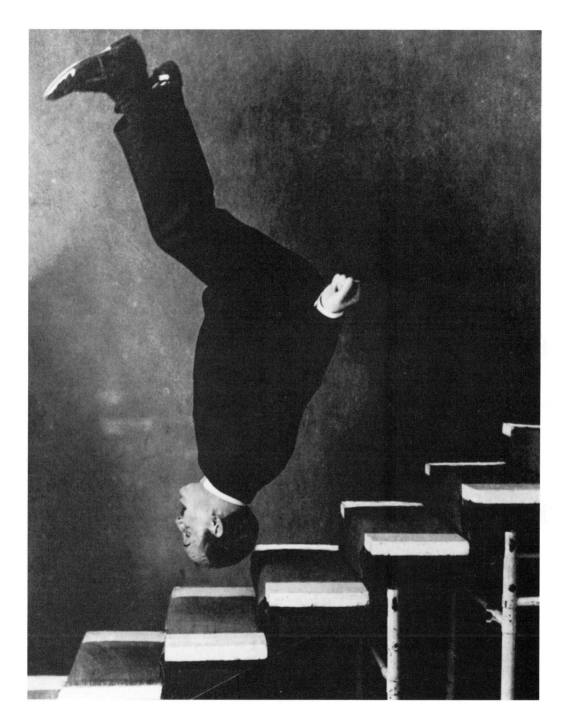

**UP THE DOWN STAIRCASE (1928)**

Alexandre Patty, of Germany, "walking" downstairs on his head. Patty could do
twelve stairs up, nine stairs down and performed with the Ringling Brothers Circus.
*(Courtesy RIPLEY'S BELIEVE IT OR NOT!®)*

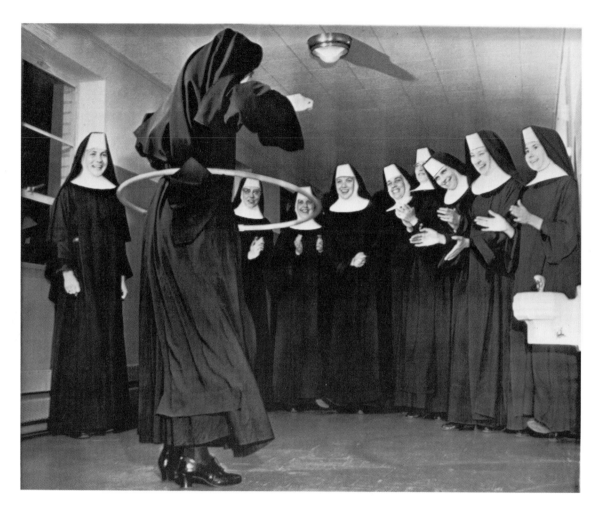

**HULA HOOP HABIT (1958)**

Benedictine Sisters at the Christ the King Convent, Oklahoma City, Oklahoma, cheered when their sister took a Hula Hoop for a spin.

*(Courtesy Buffalo and Erie County Historical Society)*

# SCIENCE, MEDICINE AND TECHNOLOGY

There is something fascinating about science. One

gets such wholesome returns of conjecture out of such

a trifling investment of fact.

Mark Twain

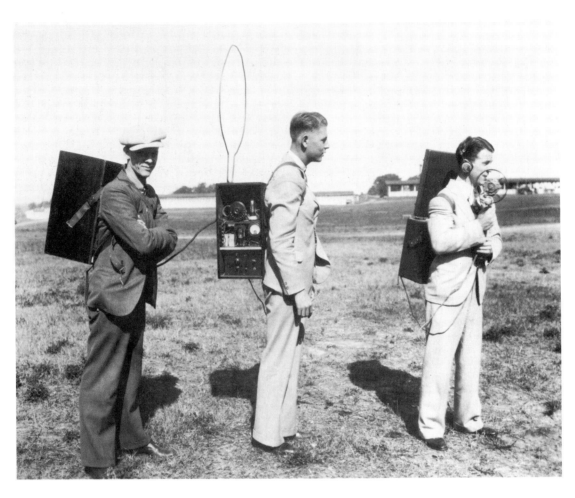

**EYEWITNESS NEWS (1932)**

WPTF early on-the-spot VHF radio remote unit. Operated on 69 m.ca. as W4XD, this was a "home-made" radio relay station. Left to right: Andrew Massey, chief engineer; Willard Dean, WPTF control operator; Henry Hulick, WPTF control operator (later chief engineer).

*(Courtesy North Carolina Collection, University of North Carolina Library at Chapel Hill)*

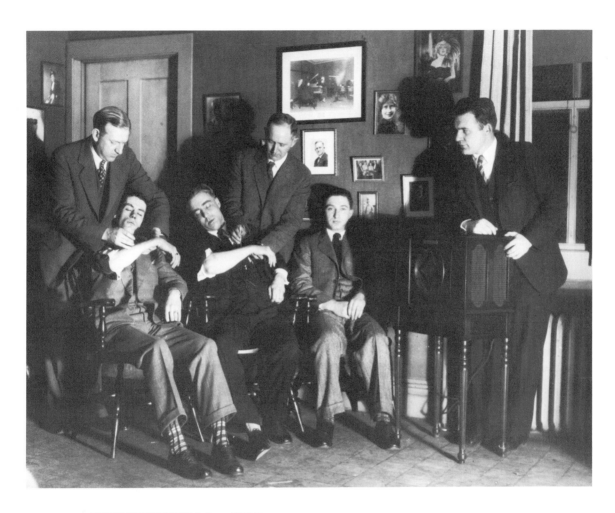

**RADIO HYPNOTISM (circa 1927)**

The photograph shows researchers testing subjects for signs of "trance state" by pricking with needles. The experiment was designed to see if hypnosis could be induced by radio transmission.

*(Underwood and Underwood; courtesy Underwood Photo Archives, San Francisco)*

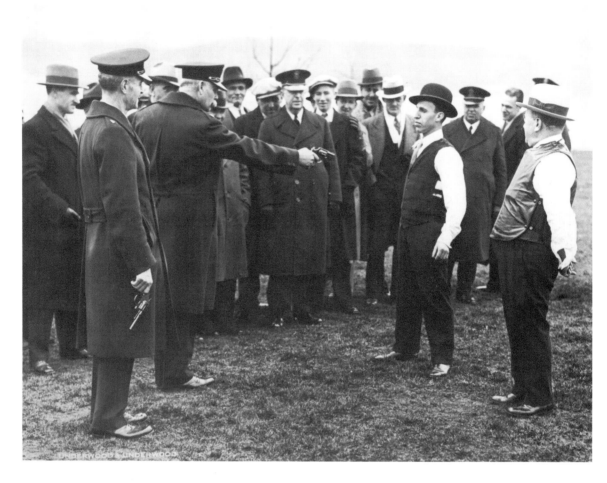

### COPS TEST BULLETPROOF VEST ON INVENTORS (1931)

Two inventors (who apparently had plenty of confidence in their product) faced
without flinching the smoking pistols of Washington police officials, in a spectacular
demonstration of their new bulletproof vest. The photo shows Inspector Albert J.
Headley aiming at the bosom of Leo Krause, while Jack Schuster, the inventor,
also wearing the garment, and Inspector Thaddeus R. Bean await the result
with interest.

*(Underwood and Underwood; courtesy Underwood Photo Archives, San Francisco)*

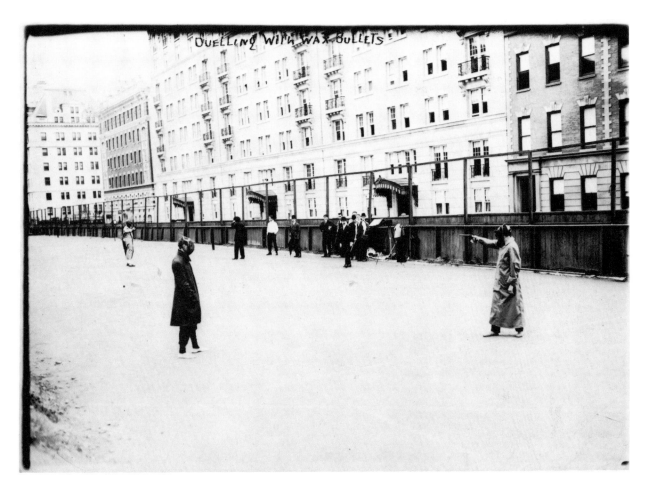

**DUELING WITH WAX BULLETS (1909)**

Napoleon had a point when he said, "It is too bad that death often results from dueling, for duels otherwise help keep up politeness in society." Dueling with wax bullets allowed marksmen to take aim at each other—without all the mess.

*(Bain Collection; courtesy Library of Congress)*

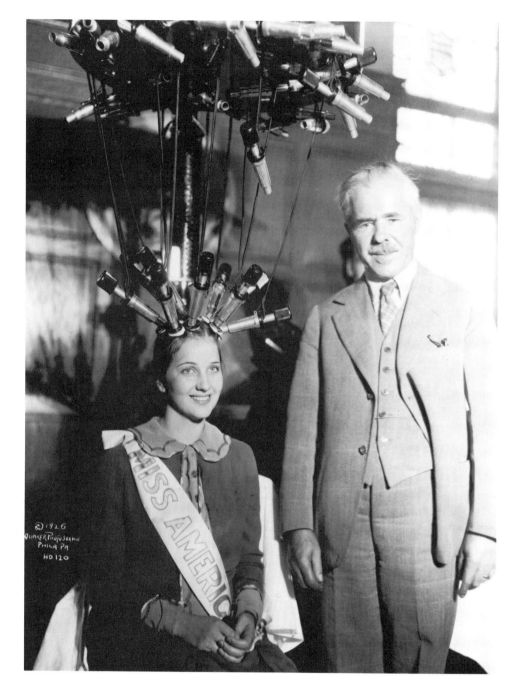

**HAUTE COIFFURE IN THE QUAKER STATE (1926)**

Always on the leading edge of fashion, this Miss America sets the pace with a permanent wave.

*(Quaker Photo Service; courtesy Library of Congress)*

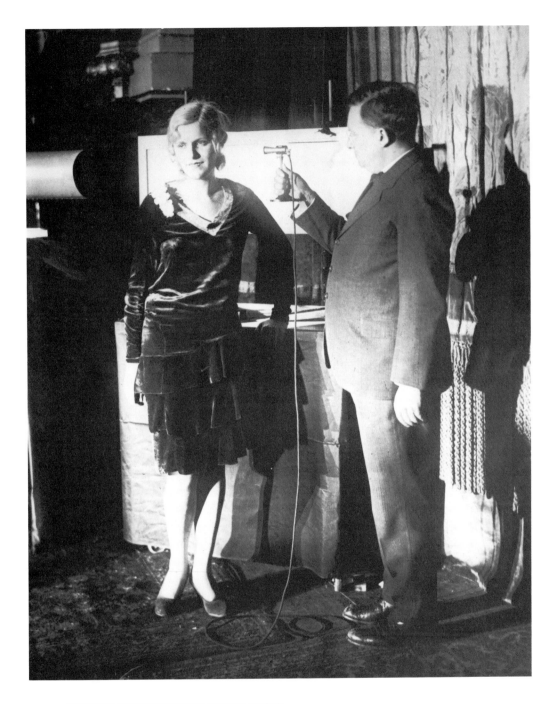

**SCIENCE REGISTERS THE BLUSH (1929)**

Dr. E. E. Free, of New York University, demonstrated the Heat Wave Detector at a convention held by scientists at the Hotel Astor. This instrument was delicate enough to register the blushes (which are heat waves) in a girl's face. The photo shows Johanna Allen doing the blushing for Dr. Free at the demonstration.

(The New York Times; *courtesy National Archives and Wide World Photos*)

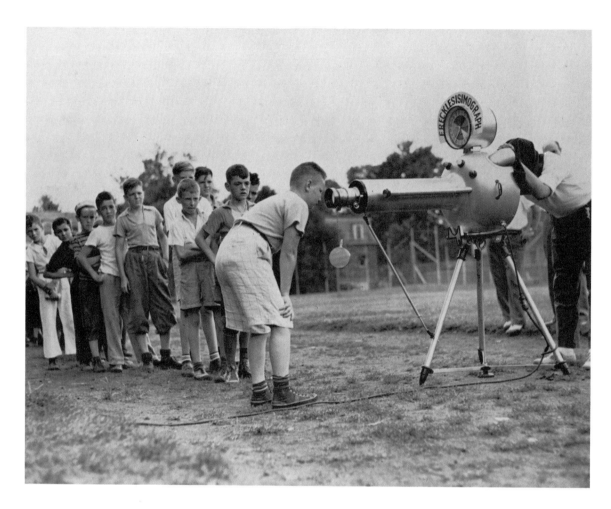

## FRECKLESISIMOGRAPH (1939)

Freckles were counted in a Freckles Contest at Germantown Boys Club. The boys-only contest was almost won by 9-year-old Dorothy Nickles, who was found out only when the yachting cap covering her long hair was pulled off. Another contestant was disqualified when it was discovered that many of his prizewinning freckles had been painted on. Awards were offered for largest boy with smallest freckles, smallest boy with largest freckles, most freckles, best freckles, and fattest freckled boy.

*(Prinz,* Philadelphia Inquirer; *courtesy Urban Archives, Temple University)*

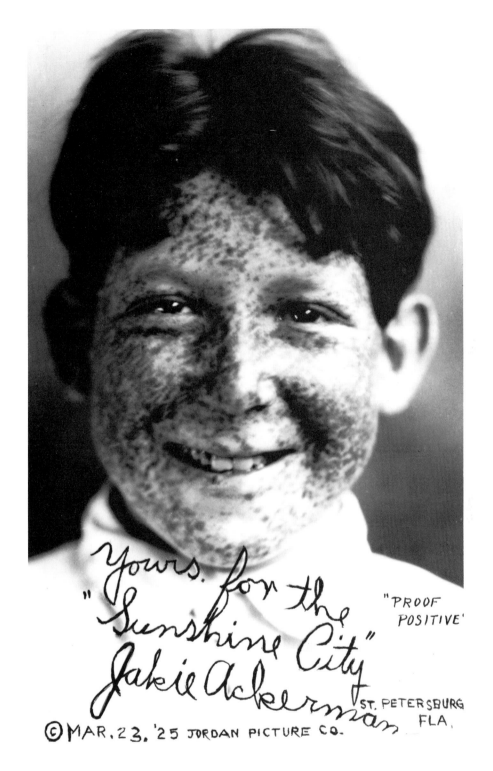

**PROOF POSITIVE (1925)**

Freckle display in St. Petersburg, Florida.

*(Jordan Picture Company; courtesy Library of Congress)*

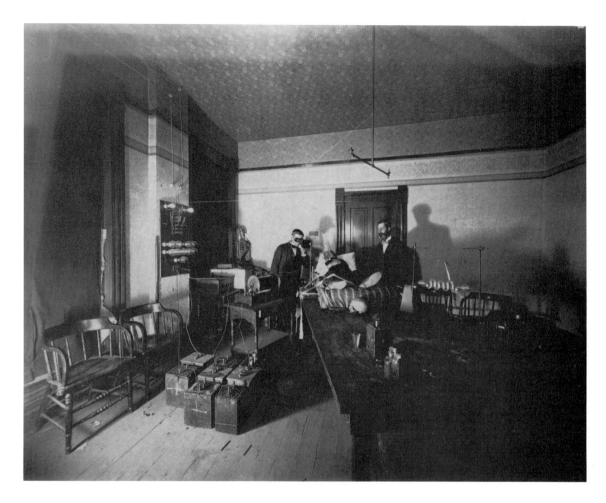

**FIRST COLORADO X-RAY (1896)**

Dr. Chauncey Tennant, Jr. (right), making the first diagnostic X-ray in Colorado at Denver Homeopathic Medical College. The patient was a city marshal at Central City suffering from a gunshot wound. The pioneering 20-minute X-ray located the bullet, which unfortunately could not be removed.

*(Harry H. Buckwalter; courtesy Colorado Historical Society)*

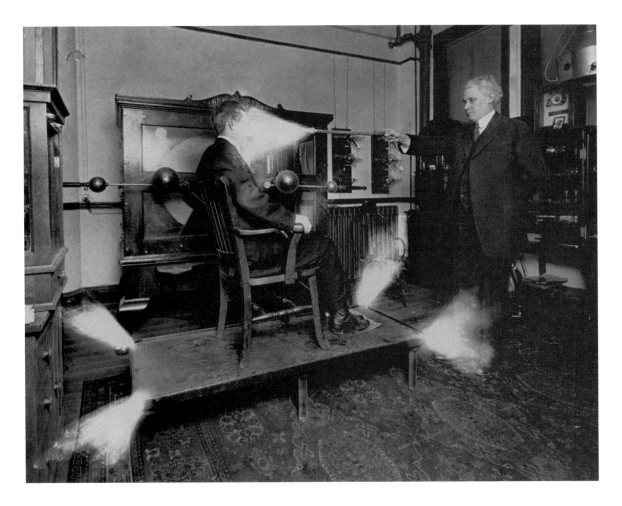

**BURNING OUT NEURALGIA (1911)**

Professor Edward G. Wilkinson here shown burning out neuralgia with electricity.
The human torch effect was applied to Dr. L. R. Newbold, who lived at the Elmo
Apartments, 112 N. 17th Street, Philadelphia.

*(Clement Congdon, Philadelphia News Service; courtesy Urban Archives, Temple University)*

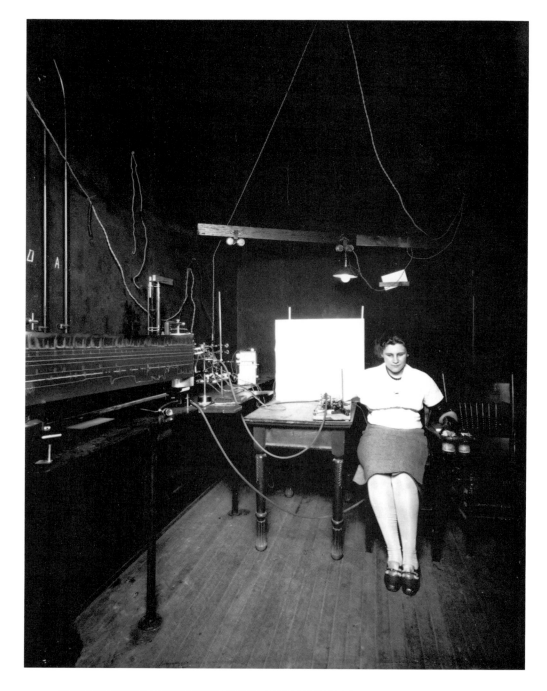

**PROFESSOR HULL'S PSYCHOLOGICAL LABORATORY (1928)**

Hull set out to chart the ulterior reaches of the human psyche at the University of Wisconsin.

*(Diemer; courtesy State Historical Society of Wisconsin)*

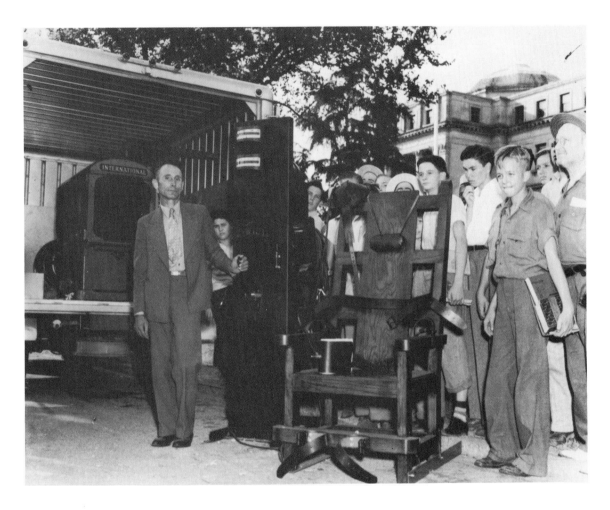

**MISSISSIPPI'S PORTABLE ELECTRIC CHAIR (circa 1945)**

Mississippi's executioner and portable electric chair toured the state giving demonstrations using cabbages (which exploded) to deter any criminals in the making.

*(Emmett L. King, Sr.; courtesy Mississippi Department of Archives and History)*

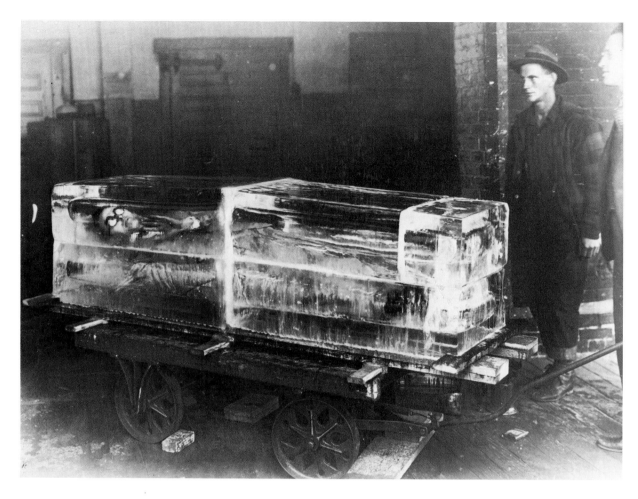

**FROZEN ALIVE (circa 1923)**

It wasn't cold enough for him, it seems. Thrilling thousands at the annual
Newspaper Mens' Midnight Frolic in Portland, Oregon, Mr. Moro successfully
conducted his scientific experiment, which consisted of being frozen in a cake of ice
for a period of thirty minutes and then being chopped out alive. The science of
cryogenics owes much to pioneers like Mr. Moro.

   Blockhead or genius? You decide.

*(Underwood and Underwood; courtesy the Bettmann Archive)*

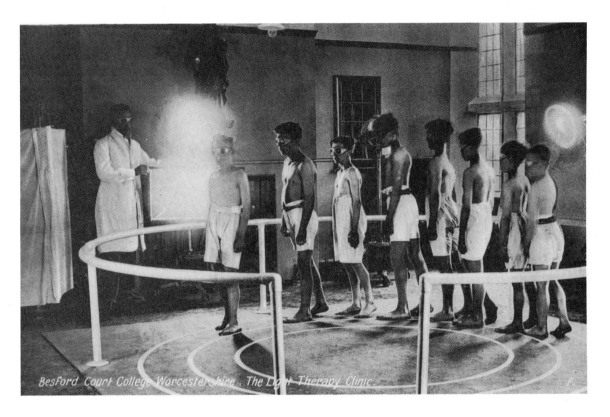

Besford Court College Worcestershire. The Light Therapy Clinic

**BRIGHT IDEA (circa 1920)**

No one knows who first thought of this curious cure for what ails you, but the Light Therapy Clinic at Besford Court College in Worcestershire, England, had patients lined up in the 1920s.

*(Courtesy Ellen Salwen Collection)*

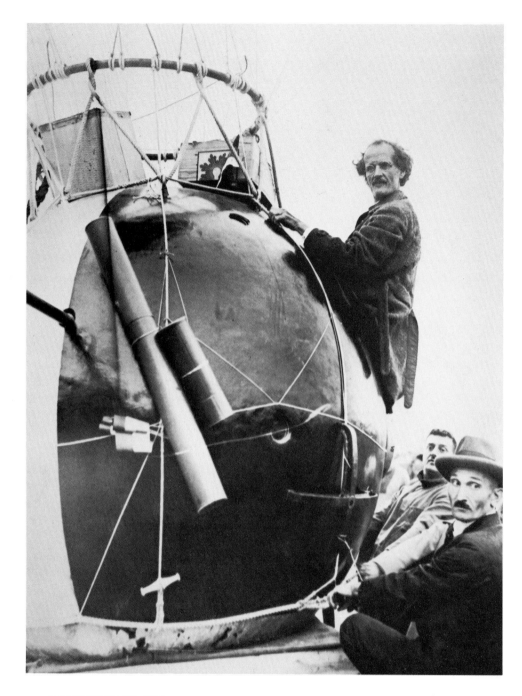

**STRATOSPHERIC ASCENT (1931)**

Professor Auguste Piccard and his assistant (both from Augsburg, Germany) were the first to ascend into the stratosphere, long considered the last frontier in aviation. Many people of Piccard's day thought that a balloon, on entering the stratosphere, would come crashing straight back to earth. Piccard's flight, however, was successful, reaching an altitude of 52,462 feet.

*(Courtesy Buffalo and Erie County Historical Society)*

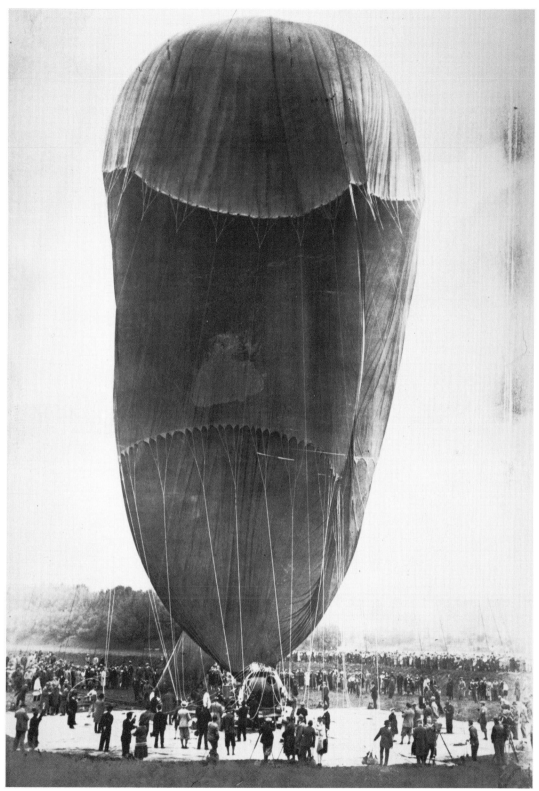

*(Courtesy Buffalo and Erie County Historical Society)*

# LIGHTER THAN AIR

It seems to me that man is made to act

rather than to know: the principles of things escape

our most persevering researches.

Frederick the Great, 1783

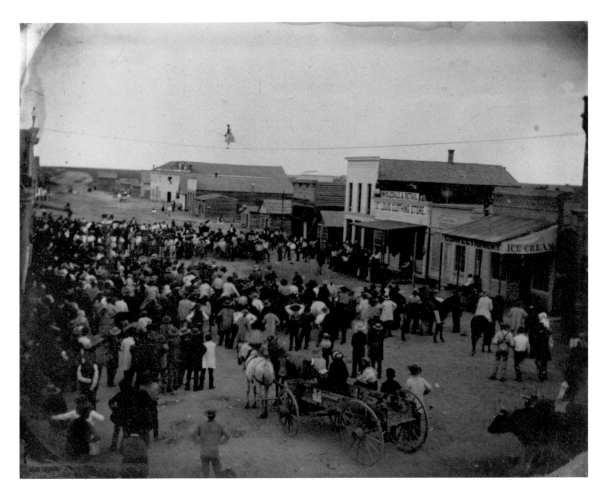

**HIGH OVER THE MILE HIGH CITY (1861)**

A crowd gathered in Denver to witness Madame Carolista's daring tightrope crossing of Larimer Street. Performers such as Madame Carolista traveled the country advertising their stunts with handbills and in newspapers, perhaps passing a hat to collect.

*(George Wakely; courtesy Colorado Historical Society)*

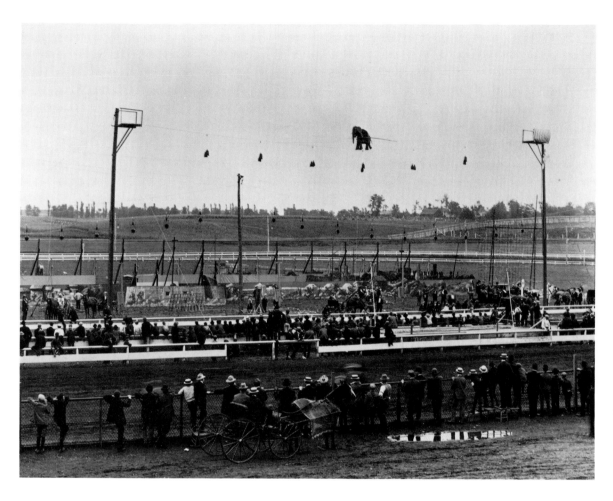

**ELEPHANT IMPERSONATORS—ON A HIGH WIRE (1900)**

These pachyderm imposters pranced along a wire over the grandstand at the
Minnesota State Fair.

(Minneapolis Journal; *courtesy Minnesota Historical Society*)

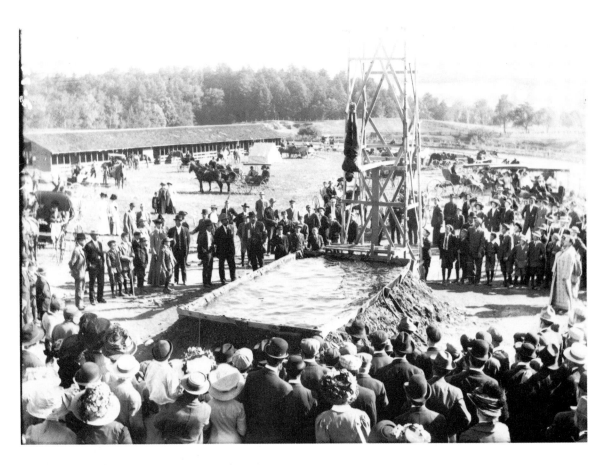

**MAN DIVING OFF TOWER AT OTSEGO, NEW YORK, COUNTY FAIR (1910)**

The science of tower diving involves geometric calculations based on the height and weight of the diver, the distance to the water, and the angle of entry to determine the depth of the tank. Another figure taken into account is that 86 percent of all Americans are acrophobic.

*(A. J. Telfer; courtesy New York State Historical Association)*

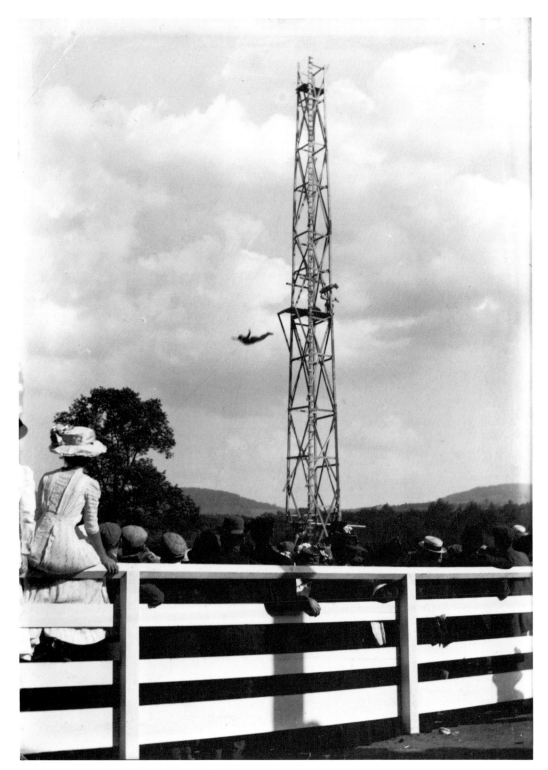

*(A. J. Telfer; courtesy New York State Historical Association)*

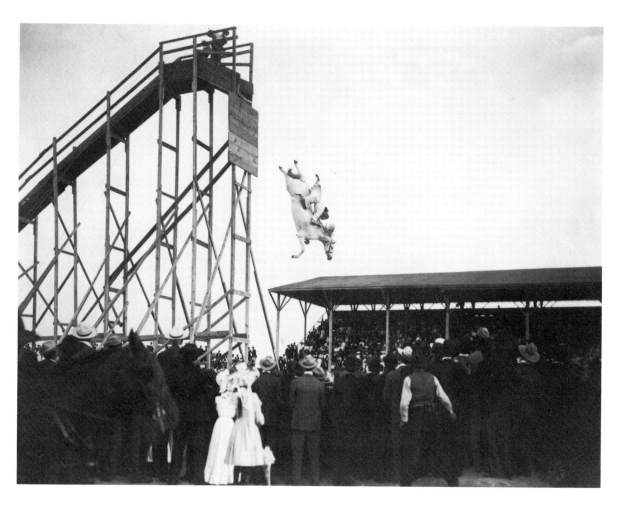

**THE DARING RIDE OF MRS. EUNICE PADFIELD (1905)**

At a July Fourth celebration in Pueblo, Colorado, Mrs. Eunice Padfield and her brave horse thrilled crowds when they plunged from a high platform toward a pool of water below. Both Mrs. Padfield and her mount survived the daring ride.

*(C. E. Holmbor; courtesy Library of Congress)*

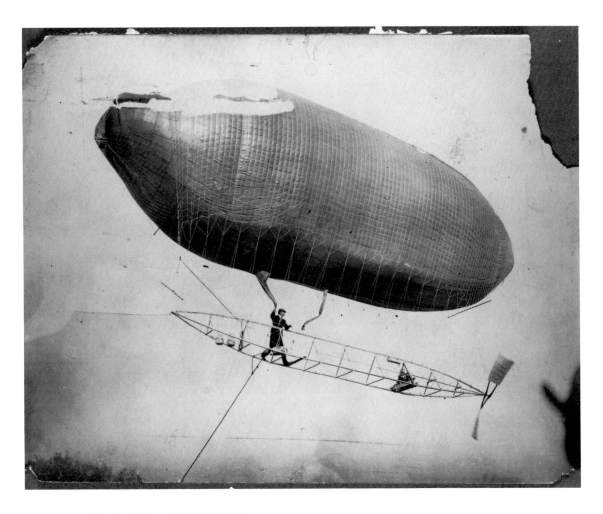

**UP, UP AND . . . ? (circa 1920)**

An unknown pilot adjusts his ballast, preparing, he hopes, to leave terra firma
for the thrills of thin air.

*(Courtesy Chicago Historical Society, #ICHi-13718)*

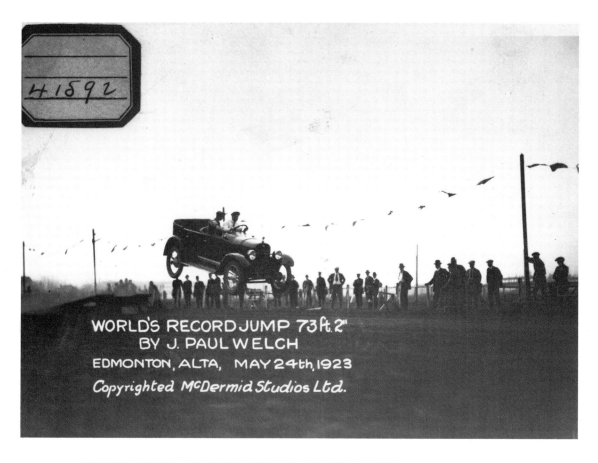

WORLD'S RECORD JUMP 73ft.2"
BY J. PAUL WELCH
EDMONTON, ALTA, MAY 24th, 1923
Copyrighted McDermid Studios Ltd.

**WORLD'S RECORD JUMP AT EDMONTON, ALBERTA, CANADA,
73 FEET, 2 INCHES (1923)**

In the days before newfangled, high-performance shocks became standard,
landing an airborne auto must have rivaled the flight for excitement.

*(Courtesy National Archives of Canada)*

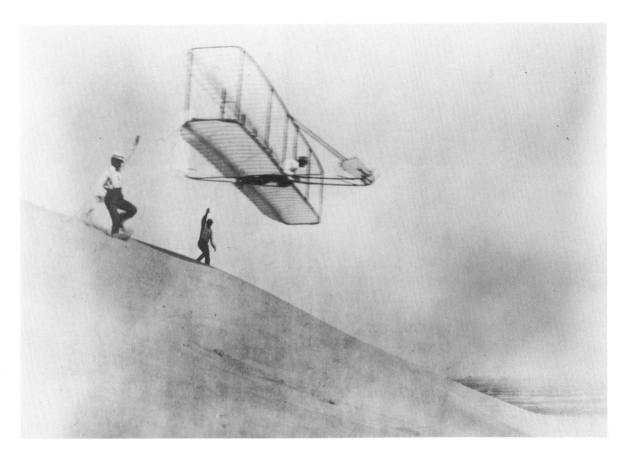

**ORVILLE, WILBUR, AND DAN (1902)**

Orville Wright and Dan Tate launched a glider in 1902 with Wilbur Wright aboard. On December 17 of the following year, Orville piloted a gasoline-engine flying machine 120 feet for 12 seconds on the first powered flight at Kitty Hawk, North Carolina.

*(Courtesy Library of Congress)*

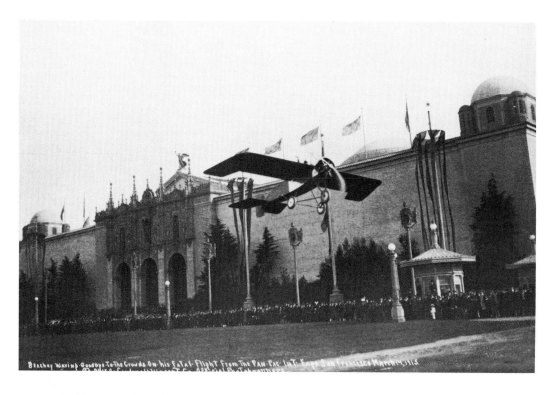

Beachey Waving Goodbye To The Crowds On his Fatal Flight From The Pan-Pac. In T. F. San Francisco March 14, 1915

## BEACHEY'S FINAL FLIGHT (1915)

Lincoln Beachey, the famous daredevil aviator, waved farewell to crowds gathered at the Pan-Pacific International Exposition at San Francisco, California.

*(Cardinall-Vincent Co.; courtesy California Historical Society)*

Diver From U.S.S. Oregon Descending To Search For Beachey's Body & Wrecked Aeroplane©P.P.I.E. Cardinall-Vincent Co. Official Photographers

## THE SEARCH FOR BEACHEY'S BODY

*(Cardinall-Vincent Co.; courtesy California Historical Society)*

Buyers and Sellers get together through the Classified Advertising Columns of THE CHRONICLE

# San Francisco Chronicle
### LEADING NEWSPAPER of the PACIFIC COAST

FAIR

Weather Report

VOL. CVI.     SAN FRANCISCO, CAL., MONDAY, MARCH 15, 1915.     X    CITY    NO. 59.

# LINCOLN BEACHEY FALLS TO HIS DEATH
## Monoplane Crumples and Plunges From a Height of 2000 Feet

## GREAT CROWD APPALLED BY THE TRAGEDY

### Throng of Fifty Thousand at the Exposition Horrified by Daring Aviator's Last Brave Battle With the Elements

LINCOLN BEACHEY, whose daring as an aviator has echoed round the world, was claimed by the elements he so long defied yesterday afternoon. The new German Taube, in which he had hoped to demonstrate his complete mastery of the air, folded its toy-like wings and plunged from a great height into the waters of the bay.

Before the horrified gaze of 50,000 people who had witnessed his flight from the Marina, in front of the Palace of Mines, at the exposition, the peer of all aerial champions went to an end as spectacular as his remarkable career.

**ON HIS SECOND FLIGHT.**

Beachey was on his second flight after having thrilled the spectators with a series of graceful loops and successfully had flown upside down across the blue expanse at a height of 2000 feet, when the monoplane collapsed on the descent. Quivering for a fraction of an instant like a wounded bird, the machine, shrouded and vapor, hurtled down amid a dead weight.

In that fraction of a moment it was apparent that Beachey still exerting the nerve that made him famous endeavored to direct his course for the bay. But the Taube was beyond human control.

**FELL INTO THE DOCK.**

The litter of wreckage shot into the water between the transports Logan and Crook lying at the Fort Mason Government piers. Strapped in the aluminum body of the car, Beachey disappeared beneath the waves. When the rescuers arrived a moment later there was hardly a ripple on the surface. Only a small piece of the wooden frame floated to mark the spot where the hero of the air had gone to his doom.

Just what caused the harrowing tragedy is a matter of supposition. Even experts and Beachey's mechanicians cannot definitely account for the disaster. The monoplane was faster than anything that the daring aviator had ever piloted and of a type with which he was not so familiar as with the biplane in which he had made over a thousand loops.

**WHEN THE MONOPLANE FAILED.**

In looping the loop a few minutes before Beachey may evidently in complete control of the machine and also as he made the up-side-down flight. It was as he straightened out for the perpendicular dive to the green that the new monoplane failed him. He had often dipped from as great a height in his biplane, but the double strain he had withstood the tremendous pressure which was now exerted on the single fan of the Taube. The propeller's revolutions were reduced, for it could be plainly seen turning over.

Then it was that the admiring exclamations of the spectators became a great overwhelming sob of anguish, heart-rendings.

Within 300 feet of the earth the wings could no longer hold. They crabbed and closed about the little car, from which trailed a wake of fire and smoke.

"Oh, God!' Beachey is great" was the cry that came from thousands of blue-trembling lips.

For a moment that, vast aston-

(Continued on Page 6, Column 4.)

### Drowning Cause of Beachey's Death

ASPHYXIATION by immersion—drowning—the direct cause of Beachey's death, according to Dr. David E. Stafford, autopsy surgeon of the Coroner's office, who made a minute examination of the remains. There were a lacerations of the scalp, a few bruises on the face, the right eye being closed, and the right leg was broken above the knee. These injuries in themselves, said Dr. Stafford, were not fatal, but had the unfortunate aviator struck the land instead of the water he would not have had a chance to survive, as his body would have been mangled.

faced thousand stood frozen with terror.

Then hope and panic gripped them alike. Beachey, this born the youth who had convinced others of his often-expressed confidence that he would never be killed in the "game," they thought could not have been vanquished by the elements to which he was so closely attuned.

Mumbling hysterically, they moved in a great mass in the direction where the machine had disappeared behind the outer buildings.

"Maybe he'll land in the water!" Beachey can't be killed!" were now the cries as the throng rushed toward the eastern fence. Even the guards, white-faced, too, could not stem that sympathetic tide. Thousands poured through the work gates, tripping and stumbling, before the exposition police mastered the situation. But the hope was in vain. Around the transport wharves the crowd swarmed, breathless, only to watch the grapplers and divers pry into the secret of that hideous sight concealed by the bright, placid waves.

Beachey, "the daredevil of the air," had paid the penalty for his valor.

**HIS LAST FLIGHT.**

"I was only sliding around; I'll do better this time," were Beachey's final words, uttered to a group of newspaper men just before he made his last climb into the sky.

He had never appeared more confident than he was then. The fact that he was about to attempt his most daring and dangerous feat in a new

## BEACHEY'S CONFIDENCE IN SAFETY IN THE AIR

BEACHEY'S supreme confidence in his ability to master the elements is vividly shown in the following autograph which he inscribed in the register of the Press Club at the exposition, following his spectacular flight on Washington's birthday:

The San Francisco Press Club, February 22, 1915.

"Gentlemen:—I have demonstrated today my theory that there is safety in the air. You cannot ruffle the feathers of nature. The next big battle of speed will be between aeroplanes. You do not have to worry about blowouts, mud, turns or frictional accidents.

"The same rain which today postponed the Vanderbilt Cup race, in which were entered thirty-two of the world's greatest drivers and cars, served admirably as a delectable garnish to my loop-the-loop flights.

"My slogan is 'Rain, shine or cyclone.'"

LINCOLN BEACHEY (inserted signature).

### Stockton Man Tries to Commit Suicide
**J. L. Engle Takes Bichloride of Mercury Tablets While Talking to a Friend**

Special Dispatch to The Chronicle.
STOCKTON, March 14.—J. L. Engle is at the Emergency Hospital in a serious condition, following an attempt to take his life by swallowing five bichloride of mercury tablets. Other than to say he was tired of life and preferred death to the difficulties under which he was laboring Engle refused to talk.

While talking with a friend, the despondent man suddenly produced a bottle, removed five tablets from it and placed them in his mouth, following the action with the remark that he was going to die. The friend promptly called an ambulance and rushed him to the hospital.

**COURTESS BISMARCK WEDS.**

BERLIN, March 14.—The marriage of Countess Hannah von Bismarck, granddaughter of the famous Chancellor, to Captain von Bredow was announced today by the Overseas News Agency.

**GERMAN PLANE WRECKED.**

LONDON, March 14.—The wrecking of a German hydroplane off the Dunkirk coast is reported in a dispatch from Copenhagen to the Exchange Telegraph Company. It is said that the crew of the plane were captured.

Lincoln Beachey, the famous California aviator, who dived to a spectacular death while attempting one of his thrilling aerial feats in a new monoplane at the exposition grounds yesterday, and Miss Ethel Shoemaker, who was his fiancee. The news of the tragic end of the daring birdman was withheld from Miss Shoemaker, as it was feared the consequences would be serious with her. Below is a photograph of the wrecked monoplane, in which Beachey's body was still securely strapped, as it was being hoisted out of the water alongside the Army transport Crook. Bluejackets from the battleship Oregon are cutting the lashings to release the body.

### BEACHEY'S MOTHER WAITS FOR HIM TO COME HOME
**She Is Told of Her Son's Death, but Refuses to Believe It.**

In her little home at 1244 Fifth avenue, Mrs. Amy Beachey, who is more than 60 years old, sat up until a late hour last night waiting for her son Lincoln to come home. She was told as gently as possible that Lincoln had been killed, but the news seemed to daze her, so that she refused to believe it, and it is feared that when realization of the truth does come her condition will be serious.

She was a happy mother yesterday afternoon, for her son was to have his Sunday dinner at her home. It had been his habit immediately at the conclusion of every flight to call her up and let her know that he was safe, because he was coming to dinner, but, however, she did not expect that yesterday.

The mother will soon receive a token of what the expedition management thought of her boy. Several days ago a beautiful medal commemorative of Beachey's two years as an aviator, and of the esteem in which he had worked to make the exposition a success, was ordered by the exposition management. It would have been his right and he would have carried it with him to his death had it not been for the fact that it was not quite finished.

Thurwald Mullaliy, director of special events at the exposition, said last night that he would give the medal instead to the mother. Mullaliy said a courier to Sunday when making the announcement and said: "I consider him one of the nicest fellows I ever met."

Beachey has a brother, Hillery, 34 years old, who also is an aviator. His father, W. C. Beachey, is an old soldier and is an inmate of the Soldiers' Home of Dayton, Ohio.

### Decision Withheld at Veterans' Home
**Hearing of Charges Against Nurses in Yountville Institution Is Concluded.**

Special Dispatch to The Chronicle.
NAPA, March 14.—The taking of testimony in the hearing by the State Civil Service Commissioner of the charges against nurses at the Veterans' Home in Yountville was concluded today and the testimony was included in the institution data last night.

The Commissioner took the testimony under advisement and will render his decision in a few days as to whether the suspension of the nurses shall be made permanent or not.

Miss Kate Green, a nurse, testified on behalf of Miss Noland and Mrs. Black. Miss Green was resigned, following a quarrel with Dr. McRae, but has not been suspended by Commandant William Bowen or McRae.

Witnesses for Mullaliy testified that Mrs. Black and Miss Noland did several employes of the big home for the Nation's heroes that Bowen was "an old stick" and incompetent; that Miss Minna Bahr, head nurse, is incompetent, and that McRae has been in the habit of robbing veterans of their money and diamond rings.

### SUICIDE WRITES THAT WHIPPING POST CURED HIM
**Mysterious Guest at Philadelphia Hotel Leaves Statement That Corporal Punishment Is Only Way to Treat Crooks**

Special Dispatch to The Chronicle.
PHILADELPHIA, March 14.—"The whipping post cured me; it's the only way to deal with crooks."

This wrote a mysterious guest of the Hotel Windsor, who hanged himself in his room today, leaving a typewritten statement, in which he said he was a member of a band of international swindlers, the leaders of which had ordered him to commit a desperate crime on or before March 15th. In the note he admitted having committed many crimes, and having so many aliases that he could not remember them all.

The man had occupied an expensive suit at the hotel for a month. He was well dressed and had been supplied with money.

### Bandits Rob Savings Society in Spokane
**Two Men Lock Cashier in Closet, Open the Safe and Secure Sum of $96.**

SPOKANE (Wash.), March 14.—Two robbers entered the office of the Citizens' Savings and Loan Society last night, forced the secretary of the society, Robert E. Potterfield, into a closet and robbed the safe of $96. They escaped after threatening Potterfield with death if he made an outcry. The robbery took place in the largest office building in the city.

### Anton Lang Joins Corps Using Skiis
**Christus of Last Two Productions of Passion Play to Fight the French Chasseurs**

Special Dispatch to The Chronicle.
LONDON, March 14.—The Daily Mail says that Anton Lang, the Christus of the last two productions of the Passion Play at Oberammergau, has joined a new corps of troops equipped with skiis which the German chasseurs have formed to fight the French chasseurs Alpine in the Vosges.

### One of the McKnight Quadruplets Dies
**Second Born, Robert Raynard, Passes Away Suddenly From Convulsions.**

REDDING, March 14.—The second-born of the quadruplets, named Robert Raynard McKnight, born March 9th to Mr. and Mrs. C. S. McKnight, died suddenly last night from convulsions. The other three children are thriving.

### Prince of Wales Is Active at the Front
**Now Attached to One of British Armies and Is Busy From Morning Till Night.**

LONDON, March 14.—The correspondent of the Daily Mail at the British headquarters in France says the Prince of Wales is now attached to one of the armies and is kept busy from morning till night. The correspondent says he saw the Prince with the staff watching important operations. He is rated to be in the plan of operations. The correspondent says he was informed the Prince was perfectly happy, for he now feels that he is sharing the actual life of the soldiers.

### Baroness Reported Victim of Accident
PARIS, March 14.—It is rumored that Baroness Vaughan, protege of the late King Leopold, has been the victim of a terrible accident. The report cannot be confirmed.

### WAR LETTERS
If you wish to keep track of the War, read the letters of

**Will Irwin**
**T. P. O'Connor and**
**James O'Donnell Bennett**
**in The Chronicle.**

They cover every phase of the great conflict

## FIFTH SHIP SUNK BY RAIDER U-29

### Fastest of German Submarines Adds French Vessel to List of Ships Sent to the Bottom Off the Scilly Islands.

#### BRITISH EVEN HONORS IN LAND OPERATIONS

**Teuton Invaders Again Bombard Ypres, Soissons and Rheims, Where Cathedrals Suffer Further Damage.**

LONDON, March 14, 10:24 P. M.—The submarine U-29, one of the largest and fastest of Germany's under-water craft, had a successful three days off the Scilly islands and in the Brenton channel, where, on Thursday, Friday and Saturday, she succeeded in sinking four British steamers and one French steamer and in damaging three others.

The German commander gave the crews of most of the steamers time to escape in their small vessel and in some cases towed the ship's lifeboats, with the crew, to passing steamers, by which they were brought to port.

The U-29 has chased by patrol boats, but proved too elusive for them, while steamers within a mile or so of escape her found that the submarine was much faster than similar craft which had previously been sent on a mission to destroy Great Britain's oversea trade.

**SHIPPING CIRCLES UNEASY.**

With a German submarine in the waters around the Scilly islands, which lie the Shore pass on their way across the Atlantic, there is much uneasiness in shipping circles, and during the course of the day a report, which also reached the American liner New York by wireless, was circulated to the effect that one of them had been torpedoed. This report, it is believed, arose from the sinking of the Andalusia.

**AIRMEN DESTROY TRAINS.**

The British feel that they made much progress during the past week when several matters up for the issue of those steamers by the victory of Neuve Chapelle and the defeat yesterday of the Germans in their efforts to recover the ground to the British regulars on the preceding days.

**AIRMEN DESTROY TRAINS.**

British airmen also have been active again, and have destroyed a train at Don, a short distance from Lille.

The Belgian army continues to hold the line along the Yser. The French continue to hold the whole of the River Yser, and the Champagne, the Argonne and the Vosges there has been fighting of varying importance. The Germans have again bombarded Ypres, Soissons and Rheims. In the latter two towns the cathedrals have suffered further damage.

The French have occupied Ember-

(Continued on Page 6, Column 6.)

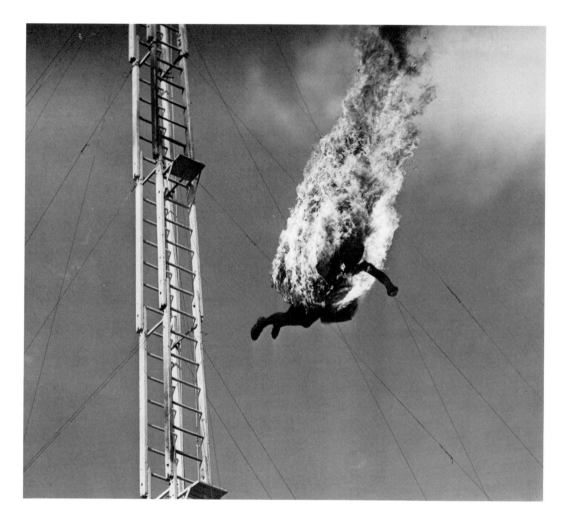

**FLAMING FREE FALL, THRILL DAY (1937)**
(Minneapolis Star-Journal; *courtesy Minnesota Historical Society*)

*Life is simply a process of combustion.*   —M. J. Schleiden, 1848

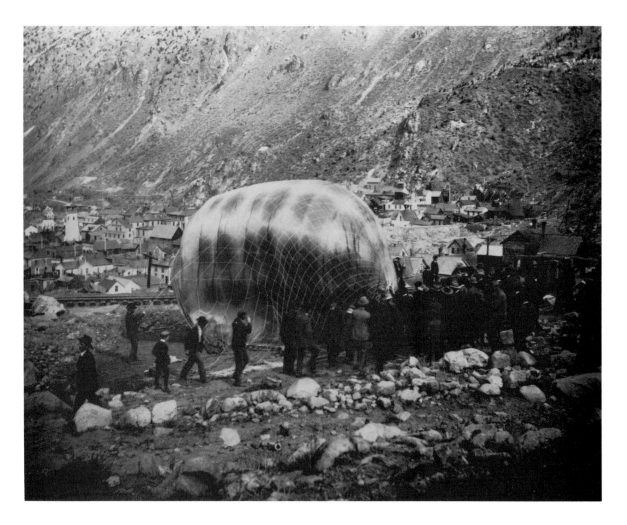

**BALLOON AT REST (circa 1895)**

On the outskirts of the mountain hamlet of Georgetown, Colorado, early aviators prepared to launch their balloon.

*(Harry H. Buckwalter; courtesy Colorado Historical Society)*

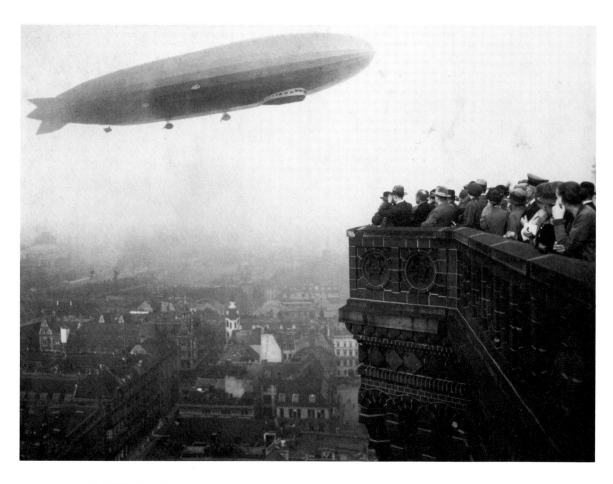

**UP FOR THE COUNT (1928)**

Named after the famous German Count Ferdinand von Zeppelin (1838–1917), this dirigible set out on its trial flight over Germany.

*(Courtesy Chicago Historical Society, #ICHi-20923)*

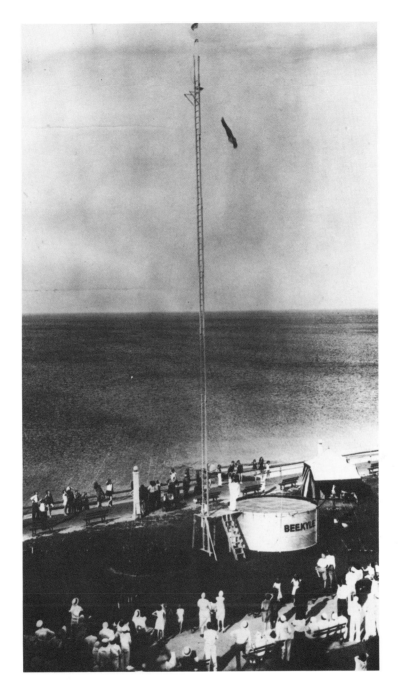

**BEE KYLE MAKING HER 286TH 100-FOOT DIVE INTO AN 8-FOOT TANK (1936)**

In 1939 *Billboard* magazine held a contest to determine who was the most popular outdoor performer in the United States. Bee Kyle won with 32,728 votes, far outdistancing the number-two choice, who had 26,746.

*(Courtesy Library of Congress)*

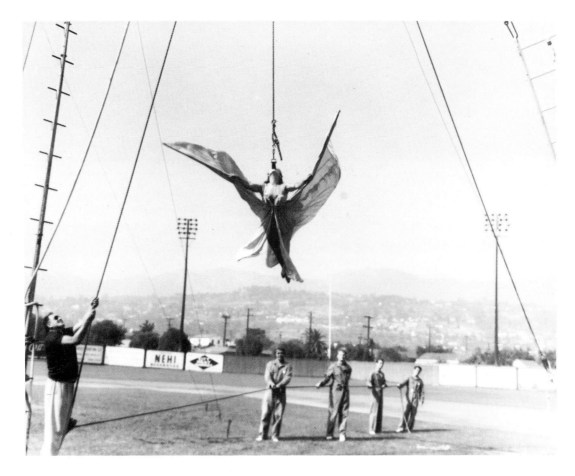

**IRON JAW ACT (1948)**

There are times when the best thing to do is keep a stiff upper lip.

*(Courtesy Circus World Museum, Baraboo, Wisconsin)*

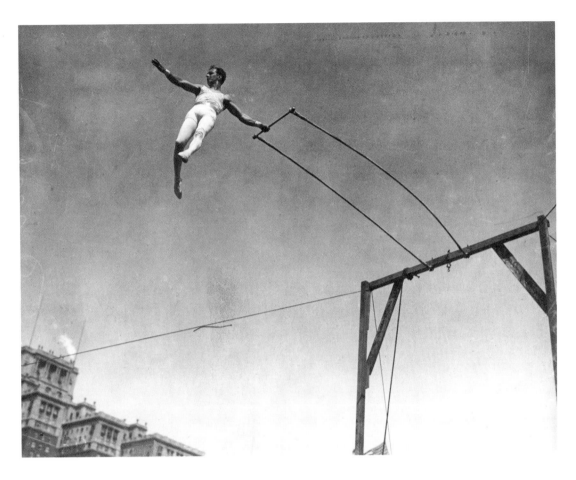

**ALFREDO CODONA (circa 1930)**

Some historians claimed that Alfredo Codona was the first to perform the triple somersault on the trapeze. This was not actually accurate, but Codona did have an undisputed and unmatched grace of form. Like many trapeze artists, he met a tragic end, though not while working. He and his second wife, Vera Bruce, were in their lawyer's office working out the terms of their divorce when Codona asked the lawyer to leave the room for a few moments. Gunshots were heard. Codona had killed his wife and then turned the gun on himself.

*(Courtesy Circus World Museum, Baraboo, Wisconsin)*

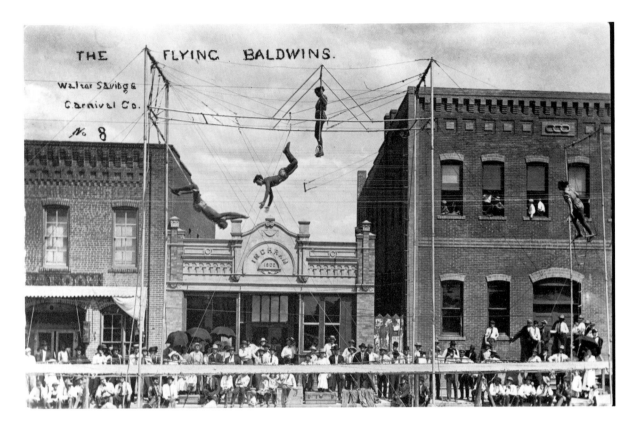

**CAUGHT IN THE ACT (1925)**

The Flying Baldwins performed their unusual acrobatics in front of
Odd Fellows Hall.

*(Courtesy Nebraska State Historical Society)*

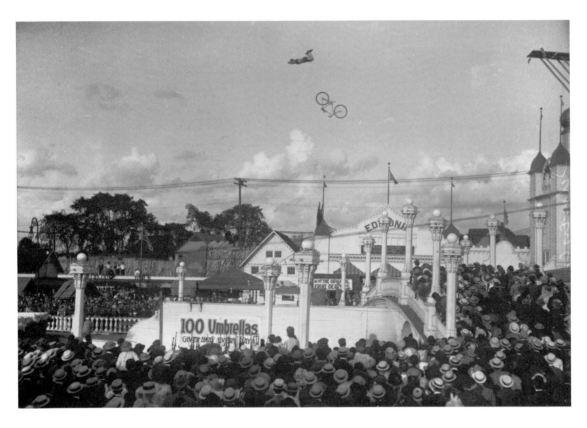

**SCHREYER THE WONDER (1913)**

At Luna Park in Cleveland, Ohio, Schreyer the Wonder abandoned his bike in mid-air, soared solo, then landed safely to gasps and thundering applause.

*(Andrew Kraffert; courtesy Western Reserve Historical Society)*

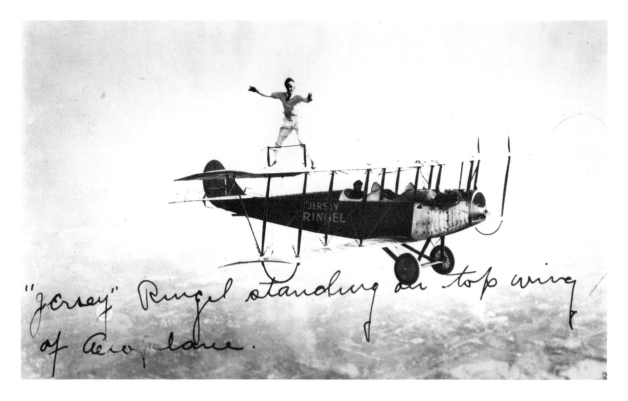

*"Jersey" Ringel standing on top wing of aeroplane.*

**THE SKY'S THE LIMIT (circa 1925)**

Wing walkers performed all sorts of aerial hijinks—from somersaults to tennis matches—for the delight of crowds below. Here, in a rare bird's-eye view, airborne ace Jersey Ringel strikes a careful pose.

*(Courtesy Library of Congress)*

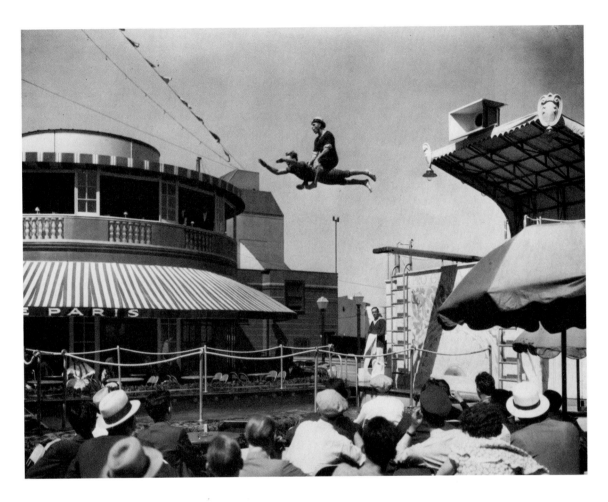

**WHOA! (1933)**

The 1932–33 Century of Progress in Chicago promised thrills that "men would remember and women can't forget." This diving act was a mere prelude to the wonders that followed.

*(Kaufmann & Fabry; courtesy Chicago Historical Society, #ICHi-20818)*

# SOURCE INFORMATION

The following listing is supplied in the hope that it will aid in bringing new (old) photographs out for viewing. The information has been provided by each of the archives or collections whose images appear in this book. For a more complete listing of visual resources available in the United States and Canada, see *Picture Sources 4*, Special Libraries Association, available in most libraries.

**ALABAMA DEPARTMENT OF ARCHIVES AND HISTORY**
624 Washington Avenue
Montgomery, AL 36130
(205) 242-4435
*Contact:* Dr. Norwood Kerr, Head, Archival Reference
Extensive collection of photos of state government officials, and a vertical file of photographs divided among places, people, and subjects.

**H. H. BENNETT STUDIO FOUNDATION**
215 Broadway, Box 145
Wisconsin Dells, WI 53965
(608) 253-2261
*Contact:* Oliver W. Reese, Curator of Photography
Still printing from the glass plate negatives of H. H. Bennett, principally known for his landscape photography along the Dells of the Wisconsin River, Devils Lake, Adams and Juneau counties, nearby Waukesha, and a few other areas in Wisconsin. Winnebago Indian life and costumes also documented.

**THE BETTMANN ARCHIVE**
902 Broadway
New York, NY 10010
(212) 777-6200
*Contact:* David Greenstein, Director
Over 25 million images. Offices staffed by professional picture researchers. Among the collections included are: Underwood & Underwood (feature and news photography 1880–1955); Penguin and John Springer (movie stills); Frank Driggs (jazz); New York *Daily Mirror* (1947–61); Oxford University Museum of the History of Science; Hulton Picture Library (UK's largest picture library); United Press International (1907–present); International News Photos (1912–58); Acme News Photos (1923–60); Pacific & Atlantic Photos (1925–60); Reuters (1985–present).

## BUFFALO AND ERIE COUNTY HISTORICAL SOCIETY

25 Nottingham Court
Buffalo, NY 14216
(716) 873-9644
*Contact:* Mary F. Bell, Library Director
Artifacts, manuscripts, books, photographs, and other materials concerning local history. 500,000-item photograph collection. Special collections include the Pan-American Exposition of 1901, Niagara Falls, the Larkin Building, and photographs by Wilbur Porterfield.

## CALIFORNIA HISTORICAL SOCIETY

2090 Jackson Street
San Francisco, CA 94109
(415) 567-1848
*Contact:* Dr. Samuel V. Kermoian,
Acting Director
The Society closed its library, including the photography department, on March 31, 1989.

## CALIFORNIA STATE LIBRARY

914 Capitol Mall, Box 942837
Sacramento, CA 94237-0001
(916) 445-4149
*Contact:* California Section
Brings together most of the State Library's documentation about California. Includes tens of thousands of images of California's social, economic, and political history, and scores of photograph albums, lantern slides, portfolios, and books with original photographs. Photographs of San Francisco, Sacramento Valley, and Mother Lode counties dominate. The collection is particularly strong in mining, agriculture, state government, transportation, and historic sites.

## NATIONAL ARCHIVES OF CANADA, DOCUMENTARY ART AND PHOTOGRAPHY DIVISION

395 Wellington Street
Ottawa, Ontario K1A ON3
CANADA
(613) 992-3884
*Contact:* Joan Schwartz, Curator of
Photography
Approximately 13.5 million photographs organized into units called accessions or collections that document Canadian history from all the provinces. An accession corresponds to all the material acquired from a source in a single acquisition. The accession is generally named after the source.

## CHICAGO HISTORICAL SOCIETY, PRINTS AND PHOTOGRAPHS DEPARTMENT

Clark Street at North Avenue
Chicago, IL 60614
(312) 642-4600
*Contact:* Larry Viskochil
Largest single source of pictorial information regarding the history of Chicago and the surrounding area. Over 1 million images, including still photographs, prints, broadsides, posters, and motion picture film, with significant holdings in American history. Also contains photographs from an ongoing documentary undertaking titled the Chicagoland in Pictures Project (1948–present) and material from the WGN-TV archive.

## CIRCUS WORLD MUSEUM LIBRARY AND RESEARCH CENTER

415 Lynn Street
correspondence to: 426 Water Street
Baraboo, WI 53913
(608) 356-8341
*Contact:* William McCarthy or Robert L.
Parkinson
Part of the Circus World Museum, owned by the State Historical Society of Wisconsin and located at the historic site of the original Ringling Brothers Circus Winter Quarters. The collection features 30,000 negatives and 60,000 photographs of the circus, plus over 7,000 lithographs, 12,000 newspaper advertisements, 400 route books, 14,000 route cards, 1,700 heralds and couriers, 1,400 programs and songsters, and much, much, more!

## COLORADO HISTORICAL SOCIETY, PHOTOGRAPHY DEPARTMENT

1300 Broadway
Denver, CO 80203-2137
(303) 866-4600
*Contact:* Eric L. Paddock
Over 400,000 prints and negatives pertaining to the history of Colorado and the West, circa 1840–present, including the 18,000-item

William Henry Jackson/Detroit Publishing Company collection (1868–1924) of Western American material, the ever-expanding *Denver Post* photograph archive, and more than 100 other discrete collections pertaining to every aspect of Colorado and Western history. Also includes a growing motion picture film archive.

## GARST MUSEUM, DARKE COUNTY HISTORICAL SOCIETY, INC.

205 N. Broadway
Greenville, OH 45331
(513) 548-5250
*Contact:* Mrs. Toni Seiler, Director
The depository of memorabilia of the Treaty of Greeneville signed in 1795. Also contains the largest known collection of Annie Oakley memorabilia, the Lowell Thomas Collection, artifacts from the crash of the U.S.S. *Shenandoah* and from its commander, Greeneville-born Zachary Landsdowne.

## GEORGIA DEPARTMENT OF ARCHIVES AND HISTORY

330 Capitol Avenue
Atlanta, GA 30334
(404) 656-2393
*Contact:* Gail Miller, Prints Archivist
Acquires and preserves official Georgia governmental records and supporting documents, administers state and local government records management programs, and makes collections available for research and use by the public. Holdings include state governmental records; county and municipal records; private papers of individuals, businesses, organizations, and churches; land records; and visual materials.

## HOUDINI MAGICAL HALL OF FAME

4983 Clifton Hill, P.O. Box 777
Niagara Falls, Ontario L2E 6V6
CANADA
(416) 356-4869
*Contact:* Henry Muller
Opened in 1968 as a shrine to the great Harry Houdini. Contains most of his memorabilia, including the Upside-Down Chinese Water Torture Cell, his private pick and key collection, the Houdini handcuff collection, and videotapes of original films of Houdini and other performers. Displays only authentic magical paraphernalia.

## KANSAS STATE HISTORICAL SOCIETY, PHOTOGRAPH COLLECTION

Center for Historical Research
120 W. 10th Street
Topeka, KS 66612
(913) 296-2624
*Contact:* Nancy Sherbert
Over 400,000 images of the history of Kansas and the Great Plains from the late 1850s to the present. Most Kansas counties and communities are represented. Major collections include photographs of the Atchison, Topeka and Santa Fe Railroad and Railway, and the work of Alexander Gardner, L. W. Halbe, Alfred Lawrence, and H. L. Wolf. Military section on the Spanish-American War, and Native American photographs organized by tribes and individuals.

## LIBRARY OF CONGRESS, PRINTS AND PHOTOGRAPHS DIVISION

Room 337, James Madison Building
Independence Ave., SE (between 1st and 2nd
    streets)
Washington, DC 20540
(202) 707-6394
*Contact:* Stephen Ostrow, Chief
The 9 million original still photographic exposures in the Prints and Photographs Division comprise one of the finest general historical collections in the world and provide a pictorial record of national and world social, cultural, and political history from 1850 to 1970. For the most part the collections do not include federally produced photographic records, which are, by law, retained by the National Archives.

## MARYLAND HISTORICAL SOCIETY, MUSEUM AND LIBRARY OF MARYLAND HISTORY

201 W. Monument Street
Baltimore, MD 21201
(301) 685-3750
*Contact:* Laura S. Cox, Prints and
    Photographs Librarian
Approximately 250,000 photographs. Includes views of Baltimore, Maryland houses, business establishments, prominent Maryland families. Collections also include 5,000 prints depicting

Maryland landmarks, Civil War camp scenes, bird's-eye views, 3,000 maps dating from the 1600s to the present, and over 1 million pieces of printed ephemera, including menus, obsolete currency, calendars, and theater programs.

## MINNESOTA HISTORICAL SOCIETY
690 Cedar Street
St. Paul, MN 55101
(612) 296-2489
*Contact:* Bonnie Wilson, Curator
    of Photography
Approximately 250,000 pictures individually indexed to names, places, and subjects, emphasizing people and life in the Midwest. Subject strengths include family life, politics, labor, industry, commerce, transportation, recreation, and Native Americans. Price list and brochure available upon request.

## MISSISSIPPI DEPARTMENT OF ARCHIVES AND HISTORY
P.O. Box 571
Jackson, MS 39205-0571
(601) 359-1424
*Contact:* Elaine Owens, Graphic
    Records Curator
Approximately 75,000 images relating to Mississippi history, including photographic paper prints, tintypes, hand colored lithographs, engravings, cabinet cards, and *cartes-de-visite.* Documents the political, social, and cultural life of the state, ranging from inaugurations to truck farming.

## NATIONAL ARCHIVES
7th and Pennsylvania Ave., N.W.
Still Picture Branch and Records
    Administration
Washington, DC 20408
(202) 501-5455
*Contact:* Fred Pernell
Depository for the permanently valuable records of the Federal Government. Contains several million photographs and other pictorial materials relating to the social, cultural, economic, environmental, technological, and political history of the United States and other countries.

## NEBRASKA STATE HISTORICAL SOCIETY
1500 R Street
Lincoln, NE 68501
(402) 471-4755
*Contact:* Martha Vestecka-Miller
250,000 images pertaining to Nebraska history in particular and Western history in general, including Solomon Butcher's unique collection of photographs of pioneer families and sod homes. Images available on microfiche through interlibrary loan.

## NEW YORK STATE HISTORICAL ASSOCIATION
Lake Road, Box 800
Cooperstown, NY 13326
(607) 547-2533
*Contact:* Milo V. Stewart
Nearly 100,000 images. The largest body of work is that of Washington Smith and Arthur Telfer, which spans 101 years of life in the Cooperstown area: portraits of local residents, scenic attractions, street scenes, parades, activities on the lake—virtually every local event for a century. Other collections include cased images, *cartes de visite,* cabinet cards, stereographs, lantern slides, albums, and loose prints, most of the latter from 1880–1920.

## NIAGARA FALLS MUSEUM LTD.
5651 River Road
Niagara Falls, Ontario L2E 6V8
CANADA
(416) 356-2151
*Contact:* Mr. J. Sherman
The museum is most famous for its Daredevil Hall of Fame, which exhibits some of the barrels, photographs, and news articles of the daredevils to challenge Niagara Falls. Galleries also include seven authentic Egyptian mummies; dinosaur fossils; ancient guns and weapons; Indian, Oriental, and Eskimo artifacts; plus dozens of historic photographs of Niagara Falls.

## NORTH CAROLINA COLLECTION, UNIVERSITY OF NORTH CAROLINA LIBRARY
CB #3934 Wilson Library
University of North Carolina
Chapel Hill, NC 27599-3934

(919) 962-1334
*Contact:* Jerry Cotten
Contains approximately 200,000 prints and negatives on North Carolina, including a file for every county in the state. Major collections include one devoted to novelist Thomas Wolfe, the negative files of North Carolina woman photographer Bayard Wooten, and a major collection on tobacco culture in the United States.

## NORTH CAROLINA DIVISION OF ARCHIVES AND HISTORY
109 E. Jones Street
Raleigh, NC 27601
(919) 733-3952
*Contact:* J. R. Lankford, Jr.
800,000 photographs pertaining to North Carolina history and culture, ranging from the Civil War to modern times.

## RIPLEY'S BELIEVE IT OR NOT!®
90 Eglinton Avenue East, Suite 510
Toronto, Ontario M4P 2Y3
CANADA
(416) 489-4666
*Contact:* Edward Meyer, Vice President,
   Exhibits and Archives
The personal papers, drawings, films, artifacts and photos of the late Robert L. Ripley (1893–1949), creator of the syndicated newspaper cartoon "BELIEVE IT OR NOT!"®, and his successors. Photographs are generally related to stories depicted in Ripley's cartoons and range in subject matter from unusual stunts to nature to architecture to Ripley publicity shots.

## ELLEN SALWEN COLLECTION
San Francisco
Private

## UNDERWOOD PHOTO ARCHIVES
3109 Fillmore Street
San Francisco, CA 94123
(415) 346-2292
*Contact:* Raymond Chipault
Approximately 1,500 categories of photographs from the world over, stretching through more than a century of events, wars, fads, humor, and history. Some of the most prominent names

in the field of photography had their start free-lancing with the Underwood organization.

## URBAN ARCHIVES CENTER
Paley Library, Temple University
13th Street and Berks Mall
Philadelphia, PA 19122
(215) 787-8257
*Contact:* George D. Brightbill
Materials relating to the social and economic development of Philadelphia and the greater Philadelphia area. Collections include the records of social service, labor, and neighborhood organizations, as well as personal paper collections. Most photographs are in the *Philadelphia Evening Bulletin* and *Philadelphia Inquirer* collections. Total holdings of approximately 5 million images.

## UTAH STATE HISTORICAL SOCIETY
300 Rio Grande
Salt Lake City, UT 84101
(801) 533-5808
*Contact:* Susan Whetstone, Curator
   of Photography
Approximately 500,000 photographs on all kinds of subjects dealing with Utah, the West, and Mormonism. Cities, towns, railroads, mining, life in the West, and buildings of all types are prominent in the collection.

## THE VALENTINE MUSEUM
1015 East Clay Street
Richmond, VA 23219
(804) 649-0711
*Contact:* Jane Webb Smith
The Reading Room houses the book and manuscript collections, the ephemera collections, and the photographic collections. Volumes include art and Richmond history reference works, rare books, and Richmond city directories. Personal and business papers, records, diaries, and scrapbooks of Richmond people and organizations are also represented along with 150 maps of Richmond and Henrico County.

## VIRGINIA STATE LIBRARY AND ARCHIVES, PICTURE COLLECTIONS
11th Street at Capitol Square
Richmond, VA 23219

(804) 786-8958

*Contact:* William Chamberlain, Director
Pictorial material of all types, including over
70,000 photographic prints and 30,000 negatives
and roughly 2,000 prints and broadsides.
Particularly strong in Virginiana, but also
contains items pertaining to the histories of the
United States and the South, the Confederacy,
and black Americans. Notable is the Harry C.
Mann Collection.

## WESTERN RESERVE HISTORICAL SOCIETY

10825 East Boulevard
Cleveland, OH 44106
(216) 721-5722

*Contact:* Kermit J. Pike, Director
Founded in 1867 and chartered to preserve the
history of Cleveland, the Connecticut Western
Reserve, and the Old Northwest Territory.
Nearly a million images, including the fourth-
best Civil War imagery collection, a complete
set of Rand-Ordway albums, and a large amount
of material on Shakers.

## WIDE WORLD PHOTOS, INC.

50 Rockefeller Plaza

New York, NY 10020
(212) 621-1930

*Contact:* Kerry McCarthy
The commercial subsidiary of the Associated
Press. Contains many of the world's most
famous images, including 16 Pulitzer Prize
winners.

## THE STATE HISTORICAL SOCIETY OF WISCONSIN, ICONOGRAPHIC COLLECTIONS

816 State Street
Madison, WI 53706
(608) 262-9581

*Contact:* Myrna Williamson, Reference
Archivist
Over 1 million items, printed and unprinted,
on Wisconsin history, development of the
Middle West, small-town life, social history,
Indians, lumbering, steamboats, railroads,
social events, Norwegian-Americans, and
German-Americans, from the 17th century
to the present.

## AUTHOR'S COLLECTION

New York
Private

**CONFEDERATE GENERAL WITH GIANT MORTAR AT PETERSBURG
NATIONAL MILITARY PARK, VIRGINIA (1930)**
*(Virginia State Chamber of Commerce; courtesy Virginia State Library and Archives)*

## ABOUT THE AUTHOR

Mark Sloan was born at the age of two to migrant missionary parents in the jungles of Borneo. He was captured by pygmies at the age of four and tattooed from head to foot. Later he was sold to P. T. Barnum (in a package deal with the Wild Men of Borneo) and went on to tour and perform as the Flying Tattoo with the noted Wallenda family. In 1932, after a "near miss" on the trapeze, Sloan decided to dedicate his life to science. He was age-regressed by Nikola Tesla and frozen alive in a block of ice by a Dr. Moro. He thawed out in the late 1950s and became a child prodigy, beating all of the World's Chess Champions (at once) at the age of nine. He is now the only living cryogenic experiment.

Laden with honorary doctorates in all fields, Sloan is also the recipient of the Nobel Peace Prize for his "selfless contributions to humankind." He now lives in an undisclosed frigid climate, where he is the director of the META Museum. *Hoaxes, Humbugs, and Spectacles* is his fortieth book. His autobiography, *An Extraordinary Life, Indeed!*, is forthcoming.

**CHILD PRODIGY MARK SLOAN, FAR OUTSHINING HIS SECOND-GRADE CLASSMATES (1963)**

Glenwood Elementary School, Chapel Hill, North Carolina

*(Photographer Unknown)*